A Treasury of New Brunswick Art and Stories II

PETER D. CLARK

Oct. 22, 2017

Published by Penniac Books, 634 Route 8 Highway, Durham Bridge, N.B. E6C 2E2.

I.S.B.N. 0-9699648-3-8

Second printing January 1999

Front Cover Water Colour by Bruno Bobak.
Back Cover Water Colour by Molly Lamb Bobak.
Printed in Canada by Centennial Print & Litho Ltd.

Canadian Cataloguing in Publication Data

Clark, Peter Dale, 1950-

The opinions expressed are not necessarily those of the author.

A Treasury of New Brunswick Art and Stories II

Includes index.
ISBN 0-9699648-3-8

1. New Brunswick — Anecdotes.
2. Art, Canadian — New Brunswick.
3. Art, Modern — 20th century — New Brunswick.
I. Title. "A Treasury of New Brunswick Art and Stories II"

FC2461.8.C53 1998 971.5'1 C98-901048-1
F1042.6.C53 1998

Introduction

"*A Treasury of New Brunswick Art and Stories II*" is the fourth in a series of books produced by Peter D. Clark, dealing with legends, characters, and places from our Province's past and present. This volume is special in that it highlights the contribution artists are making to the preservation of the Province's rich repository of folklore and stories.

Peter Clark's venture into writing began modestly with the idea that he would deal primarily with personal experiences lived in the wild places of New Brunswick, drawing as well on adventures lived and related by friends and acquaintances. From there, he has broadened his vistas to include a mixture of urban and country stories. All along the way, his research into our Province's folklore and institutions has been spurred on by a double aspiration: to preserve stories of people and places which with the passing of the players would otherwise be lost to future generations and to make these tales accessible to present and future readers. His present effort has been endorsed by illustrators whose names would figure in any current "Who's Who" of Eastern Canadian artists. In publishing "A Treasury of New Brunswick Art and Stories II", Peter Clark is making yet another valuable contribution to the cultural heritage of New Brunswick.

Acknowledgements

Several individuals have been instrumental in the compiling of this book. Dalton London offered very positive support and was a great help as my editor. June Campbell played an active role as my trusted typist. Alex McGibbon lent his expertise and ability as my Art advisor. I am deeply indebted to each and every artist for their magnificent contributions.

The courtesy and help from the Legislative and Provincial Archives, U.N.B. Library, Daily Gleaner, Sheila Hugh Mackay Foundation, and Centennial Print were greatly appreciated. Special thanks to Bob Jardine, my family, Fred Fowler, Mavis O'Donnell, Ralph Billingsley, Bill Wyton, Don McCoy, Flora Clayton, the late George Rainsford, the late W.D. Kearney, Jack Fenety, Ruth Bragdon, Jack Allen Thomson, Thomas Wilby, the late Dr. Ed Reynolds, Tom Scovil, and Harold Doherty. I'd personally like to thank the many individuals whom I interviewed for information. I'd like to thank anyone from the Boyce Farmers' Market, customers and vendors, who added their comments or suggestions to particular stories. Brian Cowan, Vernon Mooers, Bill Thorpe, Charlie Clayton Jr. and Pat Delong have served as my guiding lights.

– Peter D. Clark

DEDICATION

to
Dalton London

CONTENTS:

Front Cover Painting by BRUNO BOBAK

Bruno Bobak was born in Wawelowka, Poland and has resided in Fredericton since 1960. Bruno began his impressive art career by being a Canadian war artist during World War II. His career flourished and today he is internationally recognized and his paintings are in evidence around the world in public and private collections.

In 1995 the distinguished title of "Order of Canada" was bestowed upon Bruno for his contributions to the art community in Canada.

Back Cover Painting by MOLLY LAMB BOBAK

Molly Lamb Bobak was born in Vancouver, British Columbia. Her career flourished during World War II as an official war artist, the first woman to be given that title. Today Molly is internationally recognized and her paintings can be found worldwide in public and private collections.

In 1995 the distinguished title of "Order of Canada" was bestowed upon Molly for her contributions to the art community in Canada.

ILLUSTRATORS:

A Miramichi Master Woodcarver

There is an old adage: "jack of all trades - master of none." Robert Emery Jardine at age 76 is the exception to the rule. At first encounter, you might be fooled into thinking he is just an ordinary, down-to-earth type of individual. It's only upon entering his living room for a guided tour that you realize his uniqueness. Paintings, wood carvings, taxidermy and beautiful cabinets all handcrafted by Bob greet the inquisitive eye. It doesn't take long to realize that this humble and soft-spoken gentleman is indeed a master craftsman.

To the inhabitants of the community of Barnetville near Blackville, his reputation as a local historian, antique collector and all around Mr. Fix It has not gone unnoticed. But Bob is especially known as a superb woodcarver.

Visitors to Bob's and wife Dora's cosy hideaway, with its million dollar view overlooking the Miramichi, are recorded in the guest book. Tourists from every state in the U.S. as well as every province in Canada have dropped by the Jardines' humble abode. Some have simply come to chat while the majority have sought out Bob's special pine wood carvings.

Many New Brunswickers have never heard of Bob Jardine. His peers, however, are fully aware of his abilities, deeming his work to being of the highest quality, the detail of which is quite exceptional. He has been featured in various newspaper and magazine articles including The Atlantic Advocate. Bob tends to keep a low profile and shuns

the limelight. He has been invited on several occasions to exhibit his work at the prestigious National Art Gallery of Canada in Ottawa. Management has even offered to pay for the shipping and insure his works. Up to now, Bob has flatly refused, saying "I'm not worthy of such an exhibit - it's too high class. Maybe someday I'll go for it."

Bob tells this comical incident about an American stopping by inquiring about how he had got his start in carving. The visitor asked, 'How long have you been carving, Bob?" Bob replied, "I don't really know but my mother said that I was born in August and that Christmas, I carved the turkey."

Indeed, ever since Bob was a youngster he has whittled with a jack-knife, a Miramichi tradition passed on by his grandfather. At the age of seven Bob carved a tricycle out of wood. Throughout his teen years Bob fashioned birds, squirrels, rabbits and anything else that tickled his fancy. It never occurred to him that he was a "carver". For him, it was just a natural thing to do.

Only when Bob retired in 1975 did he fully realize the magnitude of his potential. From lifelong experience he realized that he had carved practically anything which struck his imagination. Items such as mechanical banks and the immensely popular dancing men, kayaks, canoes, moose, shore-birds, trout, salmon, ducks, crucifixes and his specialty, crooked knives are but a sample of his craft.

Bob has never taken specific requests. Instead, he has in the past told prospective customers to come over and see the finished product. He tells them, "If you like it - it's yours." So if you are a collector of art don't expect to order anything as Bob just makes what he wants today. In fact don't be surprised if he is completely sold out. He only carves 50 - 75 pieces each winter with 25 being crooked knives. Bob has never advertised and yet has developed an international market.

Over the years Bob has produced approximately 1000 wood carvings using only hand tools. He prefers working only in natural light because he claims that artificial light always shows the shadows. His famous "Miramichi Coat of Arms" is his favourite piece. There is one currently hanging in the Miramichi Salmon Museum at Doaktown. This particular work of art consists of a fishing lodge on top, a canoe and paddles directly below; on opposite sides two trout, a reel, a wet and dry fly, waders, net, fishing rod and two salmon. It measures

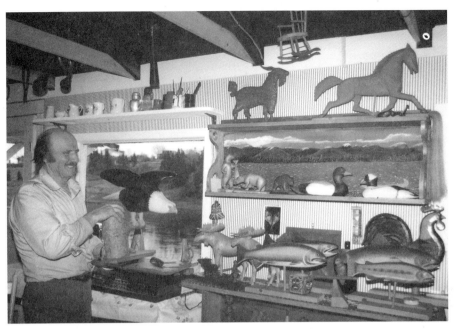

Bob Jardine

His works

approximately 16" long by 10" wide and is an incredible display of workmanship. Bob states, "That's all anyone needs to go fishin'." He has done only a handful and makes no promises to anyone about getting one.

Bob tackled a monumental task last winter. He spent countless hours in his living room carving intricate designs on window frames and door casings on both gable ends of the cathedral ceiling, leaving the beholder in awe of his accomplishment.

As I mentioned previously, Bob's forte has been carving crooked knives, with perhaps 250 to his credit. One art collector from Ontario has recently purchased two more to add to his collection, totalling 15. He sees this as an investment, figuring that someday the knives will be worth a fortune.

Bob doesn't see his craft in the same light. He does the carving "for the love of it." He claims, "When I pick up a piece of wood, I can see something in it. You know what I mean? I can see a picture take shape by just taking the right amount of wood away. Carving is just like any other art. It is not to do something as good as the other person. It is to do something that you do yourself and never mind anyone else. It is the uniqueness of the creation that makes the end product important and interesting. Time doesn't mean a thing. I take whatever time it takes to do a first-class job. To give you an example, it took two years to finish a Marilyn Monroe plaque. I may have carved another hundred carvings in between but I worked away until I got what I wanted.

I always said and maybe I'm wrong but God gave *IT* to you when you were born. I don't think you can turn an artist out of school if he or she doesn't have the special gift going in."

The Bob Jardine original wood carvings are indeed the work of a Miramichi MASTER WOOD CARVER.

Growing Up in the 1950's and 60's

Growing up in the Clark household during the 1950's and 60's was pretty typical of life in the average New Brunswick family. Here are some recollections contributed by members of the Clark family, a nostalgic look back in time which will strike a familiar chord with the baby-boomer generation and their parents. The younger generation will see these accounts as social history.

· · · · · ·

Memories
by
Dorothy Clark

I was married to Harold Chipman Clark (Clarky) on June 14, 1943. By March 13, 1944 we had our first daughter, Patricia and by July 6, 1956, with the arrival of Shirley, our family was complete with 3 boys and 3 girls.

By this time our family was living on the hill at 628 Chestnut Street. It was a bit like living in the country but still close to the centre of Fredericton. Above Green Road (later Kings College) there were only a handful of houses - no malls or businesses. From where we lived the kids could walk anywhere they wanted. They were involved

in all kinds of sports as well as Girl Guides, Brownies, Cubs and Boy Scouts. In the summer time they all joined Albert and Queen Square City run programs. On Sunday mornings the children attended St. Ann's Sunday school and church.

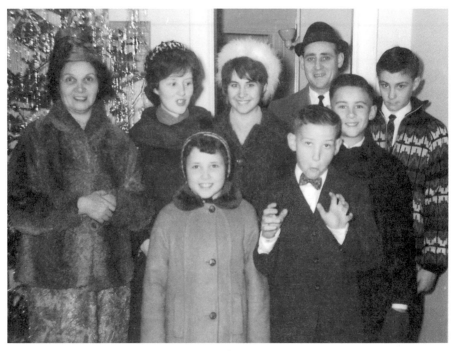

Clark Family
Front Row: Shirley, Jim Back Row: Dorothy, Patsy, Bonnie, Harold, Peter, Ron

For some reason our yard seemed to be a focal meeting place for the kids in the community. We had our yard fenced in with swings and other play toys. One day I counted 52 children in and around the house. The kids that didn't come through the house to get to the back yard jumped the fence.

You couldn't have asked for a better neighbourhood and my own children were always in the thick of things. I laughed one day when one of the neighbours commented,

"You have got the sweetest, NOISIEST kids on the block."

Life was a lot simpler in the 1950's compared with today. Money was scarce, and hand-me-downs were a fact of life in our household as they were in so many other New Brunswick families. We walked a lot

in those days and not for recreational purposes. It was simply to get from one point to another. City buses didn't exist and most people didn't have a car. It wasn't until 1955 that Clarky purchased our first car, a second-hand Chevrolet for the grand sum of sixty dollars.

Television burst on the scene in the early fifties and everyone wanted to have a nice black and white set in their livingroom. Until the time came when we could afford one we rented a set for a paltry sum of 25 cents an hour. We always had lots of quarters on hand because I had been trained as a hairdresser and regularly gave Toni Home Permanents to the ladies in the neighbourhood, charging 25 cents a do.

Our Christmas time was always special. I remember putting the toys away early in the year at Creaghans and paying on them all year long. That was what was referred to as "the lay away plan." Generally we'd all go to church on Christmas Eve.

Clarky used to lace the skates up and play shinny with the kids. He also played a lot of baseball in the summer. The kids, including Bonnie, loved to go fishing with their dad. Some school days after lunch they'd dig worms and take off, skipping school. Clarky always maintained that they'd learn more fishing than they would in school. I always had to write an excuse for the kids, but I guess it never hurt them.

We always had a dog, mostly German shepherds. One dog Cindy was extremely talented. There wasn't a trick she couldn't do from saying her prayers, to untying laces, to playing dead.

I think one of the proudest events of my life occurred at Wilmot Park. Each summer after the parks were closed the City would have contests for the children and on one occasion, five of my children won prizes. I don't think that the judges knew that they all came from the same family.

Looking back after so many years, I've come to the conclusion that Harold and I could never have found a better place to raise a family than 628 Chestnut Street.

• • • • •

There are so many events I remember at Christmas time but this is the one memory that touched my heart the most. It was the year of our Lord 1964, Christmas Eve day, and I was eight years old. On that morning every resident of the Clark household was up at the crack of dawn, scurrying around trying to get all the surprises ready.

A knock on the door around 7 a.m. and we were greeted by Mr. Adie Duncan, the Thistle Dairy milkman carrying 6 frosty glass bottles of white milk, the kind with cream on top, and a couple of bottles of chocolate milk, a special treat for us kids. Mr. Duncan marched into our kitchen and Mum, Dorothy, told him to put the bottles right in the fridge. I always remember the wonderful and kind service shown by our neighbourhood vendor.

There were six of us kids - myself, three older brothers and two older sisters as well as my mum all working as a team cleaning the house spic and span for the expected company arriving that evening. My mum's and dad's best friends, Helena and Ralph Hatto, from Saint John were expected as well as a dear friend of mine and the family, Bill MacDonald. We had a ton of laundry to do, but fortunately for my mum, the washer was located right in the kitchen. My dad, Harold, had built an area specifically for her washing chores complete with cupboards for easy storage. The convenience certainly saved my mother a lot of work as she didn't have to go up and down the 15 steps to our basement.

My dad had a certain knack for constructing anything out of wood, from porches on our house to a rumpus room in the basement. He was also very particular about his home and the food we ate. You see, he was a chef by trade, not an ordinary one but an extraordinary one. "Perfection consists not in doing extraordinary things but in doing ordinary things extraordinarily well" (Quote from Angelique Arnauld). That was my dad! My mum, too, always taught us to take pride in any job we did, to work hard and to do everything to the best of our abilities. She knew what had to be done and made sure that all of us were doing our jobs and working like a team. For a child, on Christmas Eve, minutes feel like hours. The day seemed to go on forever, with the cleaning, wrapping presents and my mum preparing all the special food for our company.

Shortly after lunch, my grandmother Violet Peabody (Bambel) arrived, delivering our presents. This was a family tradition. Bambel was very special to all of us. She was a lady full of wisdom and understanding and had a heart of gold.

After a quick supper we moved the kitchen table into the living room and set the table with white linen and our best silver and china. That was one of my favourite chores at Christmas time. I'd be so excited that quite often I would drop a plate or cup on the floor with terrible results. I was a persistent helper just trying to do a grown-up's job. The next task on our agenda around 6 p.m., was to hang our nylon stockings, one for each child. Ron would put a nail in the wall and we'd all fasten our nylons to it and write our names on top. I loved that time. I would dream of all the things I would be given. I think that was my favorite thing, dreaming. The images were so colourful in my mind. It made me feel so good inside to believe that all of my brothers and sisters and I would receive gifts in our stockings.

By now it was close to 7 p.m. and the day had been so wonderful. There was a slight problem, however. Dad still wasn't home from work. What began as a little snow in the afternoon had ballooned into a raging blizzard. The radio announced that all motorists should stay off the roads as the visibility was near zero. I remember Mum hugging me and cautioning the family that Dad might not make it home that night.

Tears streamed down my cheeks and I walked over to the picture window. With my face pushed against the cold glass, I waited vigilantly for my dad. I prayed to God to keep him safe and that if there was any way possible could He allow him to come home. I promised to be the best girl in the world if He would grant me this favour. The time passed ever so slowly and I wasn't leaving my post. Suddenly through the snow, like a miracle, I saw two headlights. Sure enough it was my dad's 1963 blue Mercury Meteor. Having my dad home was an answer to my prayers and the best Christmas present that I could ever have received but there was one more surprise to come.

My dad lifted me up in his arms and told me to shut my eyes and that he had something very special for me. He handed me a box all wrapped in shiny gold paper with a big white bow, and inside was full of pennies that my dad had collected and saved for the past year. Those pennies were like pennies from heaven to me.

My dad is gone now, but at Christmas time when the snow begins to fall and the north wind starts to blow, a tear comes to my eye and I am always reminded of that special Christmas Miracle - at 628 Chestnut Street.

Written by Shirley Violet Elizabeth (Clark) Duncan

July 6, 1998 - Born July 6, 1956

• • • • •

Our Rink

told by Ron Clark

My brother Ron Clark was one of the first Fredericton natives to earn a sports scholarship at an American school. In 1967 at age 17 he went as a goalie to Wayland High School near Boston, then on to Lennox Prep. School and finally Michigan State University where he earned his masters degree. He also had a professional try-out with Cleveland of the World Hockey Association.

Another player coming off the Clark rink was Dave Johnson who cracked the major junior ranks at age nineteen with the Ottawa 67's.

In years gone by, local rinks were a veritable Canadian institution where boys practised their skills in the hopes of one day fulfilling their dream of playing in the six team National Hockey League. Here are Ron's recollections of our back-yard rink.

• • • • •

We called our group of kids that hung around "The Chestnut Street Gang." There were Bill, Dave and Brian Johnson, Mike, Jack and Paul Jardine, Eric and Tim Howatt, Steve Swift, Bruce Murray, Steve Bradley, my brothers Peter, Jim and myself. We played sports such as football, baseball, road hockey and ice hockey against the Morells, the Wilkinses, and the Harveys to name a few. Our principal organizer of games was Bruce Murray who was a couple of years older than the rest of us.

In the fall of 1963 my dad informed the boys of the family that we could expand our small rink to around 50 feet by 40 feet. We were allowed to level an extra portion of our lawn for this. Word was put out to the gang that those who wanted to play had to help out with the levelling of the lawn. Everyone lent a helping hand because for the majority of us hockey was our favourite sport.

Dad and we boys visited the Fredericton dump regularly that fall to salvage wood and screening for the rink. By the time the first week of December rolled around we had a real rink in operation. Dad and I did most of the flooding and built two regulation size nets.

The rink was a bee-hive of activity with continuous games of shinny from early morning to dusk on the weekends. I don't remember anyone having new skates or any other type of new equipment. Everything was hand-me-down. My brother Peter wore Simpsons Sears catalogues for shin-pads. Peter and I were both rink-rats at the Lady Beaverbrook Rink and were able to get some cracked sticks on occasion. I got some second hand goalie equipment from Vernon Saunders who was the U.N.B. equipment manager. Jack Jardine and I were the regular goalies.

One day Bruce Murray brought over a one-piece hockey stick, right-shot. This was one of the first curved blades that we'd ever seen. You couldn't break it. It was great for getting the puck off the ice. I remember my brother Peter warming me up and catching me in the shins with a slap-shot. I only had my blocker, trapper and goalie stick. Boy, did that ever smart! I chased him all the way to Albert Street School.

My friends joked that I could have made the N.H.L. as a forward. They said that I had the hardest shot that they'd ever seen - the only problem was I didn't have a clue where it was going. Perhaps that explains why the Bradley and Howatt windows got broken on a regular basis. When I look back I think that those families were saints to put up with all the noise and commotion.

On our back-yard rink, we learned valuable lessons about team work, good sportsmanship and fairplay. We played the game for fun and for the love of it. The poor, the average, and the really good players all had their place on the team and all got equal ice time. Life-long bonds of friendships developed, built on mutual esteem and respect.

· · · · ·

Reflections

Told by Patricia Wright

Our family received some dreadful news in October 1957. Our mother, Dorothy, was diagnosed as having cancer. I was twelve at the time and the eldest of six children. Shirley was the youngest, only one year old. The news sent the Clark household into a state of shock and trepidation. We all cried and were like lost sheep when Mum was taken to Saint John for radiation treatment.

I remember trying so hard to be the "little mother" and helping out the best I could. One day I was so stressed that I walked into the cloak-room at school, closed the doors and had a good cry. The teacher, Miss Barnett, was very concerned to find me in such a mess. She was very supportive and sent me home with a warm hug.

Mum returned home three weeks later. I remember the day as if it were yesterday. The boys and Bonnie were at the Lady Beaverbrook Rink. I ran the distance as quick as I could to tell of our good fortune. We were all so excited and happy we couldn't believe that our prayers had been answered. That was a blessed day in our house.

We always had lots of love from Mum and Dad. During Mum's sickness, our grandmother, Violet (Bambel) Peabody made the daily trip to cook, wash and clean. Bambel was a light in the darkness that year. Dad was very thoughtful with everyone, especially with Mum. The special bonding of love that enveloped our family made the ordeal much easier.

In those days everyone helped each other when they were in need. Our neighbours on Chestnut Street were second to none. Items such as home-made bread, pies, cakes and casseroles showed up regularly.

We thank God that Mum is still alive and well today.

· · · · ·

The Record Hop

It was the summer of 1966 and I was "sweet sixteen". Mini-skirts were in and the long hair craze for guys was sweeping across New Brunswick. Terms like "cruisin chicks," "freakin' out," "gettin' stoned," "sexual revolution," "getting high," "protesting" were being used by my peers. The Beatles and Rolling Stones dominated the music charts and a young guitarist by the name of Jimi Hendrix was electrifying audiences with his genius.

On one particular Friday morning, one of my closest friends, Gary (Clem) Clarkson and I were walking to work at 6:30 a.m. Clem was instrumental in getting me a painter's job at York Structural Steel. We both made $1.25 an hour and earned every penny of it. Our conversation centred around tonight's activities and the record hop. This was to be the highlight of the day and of course we were excited. After work, we hiked a drive downtown, cashed our cheques and headed home.

When I got home I laid a $10.00 and a $5.00 bill on the table. This was for my dad for my room and board. My dad taught me the principle of paying my way in life. I still had around $40.00 left for the week and felt like a millionaire. After a steak supper and relaxing bath I dressed for the big night. G.W.G. blue jeans, white socks, penny loafers, and a white T-shirt. I was all set. I had my black comb in my back pocket along with my wallet and a 20 dollar bill. My Export A tailor-made cigarettes were in my front right hand pocket.

Clem came over around 7:00, accompanied by another friend of ours Larry (Kimble) Goodine. We hoofed it down Regent Street to the Cue 88 Pool Hall and we played a couple of games of three-way snooker.

Next, we needed a little encouragement for the dance so we engaged the services of Jerry to purchase a little beer for us. The drinking age was 21 at the time and of course we were all underage. We made the arrangements and met Jerry on the tracks not far from the Lady Beaverbrook Rink. He was loaded for bear with lots of beer and some quarts of Golden Nut wine. There was quite a crew of us teenagers, probably 50, all with the same idea. Mostly everyone knew each other and a lot of the boys also had been at the Cue 88 with us.

By 9:30 a group of us strolled the short distance to the rink where the record hop was being held. This was the big night of action. We paid the 50 cents admission fee and down onto the dance floor we proceeded. The music was good and loud and that suited us just fine. Bill (Wee Willy) Scott was the disc jockey and he had just put on Chubby Checker's hit "The Twist." Wee Willy was a smooth operator. He had a knack for getting the crowd on the dance floor whether he played an Elvis Presley song or a Buddy Holly tune. He also knew enough to throw in a few waltzes.

Young bodies were twisting and jiving to the music. Many of the girls were dancing with each other in the centre of the dance floor. Groups of teens ranging in age from 13 and up were parading around the outside perimeter, clockwise, 3, 4, 5 and 6 abreast. It was an awesome spectacle to behold, about 1500-2000 teens, no live band, but all having a time of their lives.

There were the greasers - guys with the duck-tail haircuts, slicked down with Brylcream. Remember the jingo - "Brylcream - a little dab will do ya." Besides the loafers for guys, rock boots were in. Some of the greasers had a cigarette over their right ear with a pack of smokes tucked under their sleeve. You can be rest assured the slogan, "let's get ready to rumble" was put into practice on many an occasion in the back of the rink by those who figured they had a score to settle. Most often, after the scrap, observed by crowds of cheering teenagers, the guys would shake hands, have a greater respect for each other, and come back into the dance no worse for wear.

It seemed that 8 out of 10 teenagers smoked and by 10:30, besides being a bit on the dark side, the rink air was a bit hard to take. Time for a break, so we headed back to our beer stash for a quick warm one.

By the time we headed back inside, the clock showed 11:15 - still lots of time to ask for a dance. We were still trying to be cool and selective. We must have walked 3 miles around the rink. None of us had the gumption to ask a member of the female persuasion for a dance, so we continued circling the rink. The girls looked gorgeous - some in their mini-skirts, others in shorts and mostly all with halter tops. The Shogomoc moccasins were very popular. If we looked really close some of the girls were wearing pins which, depending on which side they were wearing them, signified whether they were virgins or not.

Well - we did a lot of gawking, speculating and wondering.

As the last waltz "A Whiter Shade of Pale" wound down at 1:00 a.m. all three of us were out front to watch the Friday night ritual - "layin' rubber."

This was the era of the hot cars like Oldsmobile 442's, Pontiac 350's, Camaro 396's but the littler cars were involved as well. University Avenue quickly looked like a racing strip as each driver tried his best to outdo all the others. The police watched all this with passive bemusement.

By 2:00 a.m. we parted company - swearing that next Friday would be our lucky night.

Ian Smith

Ian Smith was born in Montreal, Quebec and has resided in New Brunswick for 24 years. He has been a professional artist for a number of years specializing primarily in cartoons and illustrations. His work is currently on display in newspapers such as the Daily Gleaner and Toronto Star. Ian resides in Harvey along with his wife and two children.

· · · · ·

Christmas at 628 Chestnut Street

told by Bonnie Clark-Wright

The Christmas of 1962 was especially memorable. That's when I first experienced the true meaning of Christmas. With six children, and on my dad's salary, our mum worked hard to make every Christmas a special time for all of us. Mum would lay our presents away the year before at Creighan's and pay on them and bring the goods home on Christmas Eve.

I remember the ordeal of getting all the stockings ready for Santa. Each of our names had been written on the wall to make sure Santa didn't make a mistake and we made a special lunch with a note laid beside

it for when Santa came down the chimney. Then Bambel, our grandmother, arrived loaded down with presents. We all opened one gift on Christmas Eve before we went to church, and the excitement mounted as the hands on the clock moved forward. Patsy and I told the boys and Shirley that we had heard Rudolf had been spotted and their eyes shone with excitement. I believe we tried to keep the Christmas spirit longer than most families and part of that spirit meant maintaining the younger children's belief in Santa. My father was placed in the Saint Patrick's orphanage in Saint John as a young boy of eight. He never returned home to his family again. At Christmas time he was just like a big kid enjoying every minute just like the rest of us.

We were always the first family awake on Chestnut Street. On this occasion, as usual, around 2:30 a.m. I sneaked down the stairs and brought the stockings back up, distributing each one to the appropriate sibling. My older sister Patsy and I both got watches in our stockings, and we were so excited. Around 3:00 a.m. I had everyone up, including Mum and Dad and we were all around the tree. I remember looking out the window and wondering why the Jardines, the Swifts and the Johnsons were still sleeping when Santa had come? Of course Peter and Jimmy got their hockey sticks and Ronnie got new goalie pads. Our "little Shirley" got a carriage and a doll. Then there were all the other gifts. To us we received so much but to others on the street our meagre gifts would not be recognized. Nevertheless we had something unique in our home that year. I feel warm inside remembering our family and the happiness we shared on that occasion.

The delightful smell of the turkey that Dad had put in the oven on Christmas Eve was an aroma that was a regular accompaniment to our Christmas gift opening ceremony. The tree lights were bright enough to see our gifts without any overhead lights probably because we had the biggest tree and more lights than anybody on the street. I remember the heated candles bubbling up and down in the lights on the tree. Dad clamped birds with long silk-tails on the tree - I thought their tails looked like little wisks. Every branch was filled with icicles as the room reflected the glitter from the lights. The whole scene was enhanced by the nearly 200 Christmas cards hanging on string strung diagonally across the living room. The decorations spilled out onto the front lawn where Santa and his reindeer, all brightly lit, guarded the homestead.

The morning passed quickly and before we knew it we were sitting down for Christmas dinner. Christmas hats came out of the Christmas party crackers. Jimmy was trying to open everyone's Christmas party favour to see what the surprise was in each one and little Shirley needed help with hers. The food just never stopped coming and I recall watching Peter and Ronnie hanging onto their drumstick for dear life. Turkey and all the trimmings and then the pies - dinner never seemed to end. It was the best meal of the year. Ronnie and Peter ate two or three helpings! Patsy, Mum, and I were still doing dishes and Ronnie was hungry again. An hour after dinner he was out making and eating peanut butter sandwiches! He rolled the bread up with the peanut butter like a jelly roll and ate five of them!

The boys played shinny hockey all afternoon on our rink in the back yard. The rest of us watched Scrooge and all the Christmas movies. Dad listened to Bing Crosby's "White Christmas" album while cracking those giant walnuts. Mum was cleaning everything up and Patsy and I got to organize everything under the tree so we all could display our presents to best advantage.

Of course Christmas wouldn't be Christmas without contacts with our friends. Helena and Ralph Hatto usually showed up, coming all the way from Saint John, and this day was no exception. They arrived around 3 p.m. with their sons Donnie and Ralph. Helena and Ralph were our parents' best friends and they're very close to Mum to this day.

I remember talking to my best friend Sheila Cheevers. We told each other about our gifts and then we talked about "guys" and who we had seen at church on Christmas Eve and we laughed as always. We still laugh and share. When everyone was played out and the house and gifts were all cleaned up, it was ready for supper again. We went through the same ordeal we did for lunch but after supper we all sat together and listened to Christmas songs and watched TV. We savoured the moment as it was not often we were all together. Dad worked long hours as a Chef at the Training School and had a second job as well. That kept him very busy.

How could I forget the Christmas of 1962? I was sixteen, and had been working part-time as a cashier at Sobey's on Beaverbrook Ct. while I was going to school. This was the first Christmas that I had any money to speak of. Because of this fact I was able to give gifts at Christmas and so experienced the true meaning of Christmas which is giving. I still remember the feeling as I watched the faces of my parents and my brothers and sisters receiving a gift from me.

Ralph Billingsley, A Master Fly-Tyer

Ralph Billingsley, a retired CNR train dispatcher, has earned the reputation of being one of New Brunswick's premier Fly-Tyers. A resident of Campbellton, New Brunswick, he is still going strong at age 79 as owner/operator of Ralph's Fly Shop. He has been tying flies for more than three decades and has tied over 100,000 flies.

Ralph eats, sleeps, and dreams about flies and fishing. His passion for tying flies is a full-flung obsession. He declares,

"What else would cause a person to rise from his bed at 3 a.m. - tie a dozen flies - go back to bed - eat breakfast - tie another dozen and on and on."

Ralph supplies many outfitters and some stores in the region with assorted flies as well as his regular customers. One of the popular flies is called "The Orange Blossom Special" which he created himself and is also displayed in the Doaktown Museum.

And Ralph has another claim to fame. When Prince Charles and Diana, the Princess of Wales, were here on their Royal Visit, the Prince, an avid fly fisherman, was presented with a selection of Ralph's flies.

There is a sign in Ralph's basement which reads:

"All flies tied by Ralph Billingsley, using the finest material available. These flies are extra strong and will stand up under all fishing sit-

Left: Bud Garner Centre: Ralph Billingsley Right: Warren Jones

uations. Should any fly unravel or come apart for any reason please return it for replacement or refund. Any flies failing to catch a salmon have obviously been fished in an improper manner and are therefore not guaranteed against failure."

Ralph has taken his fly-tying expertise a step further than most of his contemporaries. He fashions earrings, broach - pins and even clocks from feathers and furs. Even his car has personalized plates reading "Fly Tyer." Ralph caught a 43 pound salmon on one of his creations so in his case one could say that practice makes perfect.

"Ralph's Poem on Salmon Fishing"

To catch a fish
I got the gear
A rod and a reel.
And a case of beer
A big long boat
To get me there
Five thousand flies
And some to spare.
In all my travels
I have found
Salmon cost
A hundred dollars a pound.

Jack Fenety's Battle to Save the Atlantic Salmon

Days Gone By

The main Southwest Miramichi was indeed an unbelievable mecca for Atlantic Salmon back in the early 1800's. The following excerpt from George Frederick Clarke's book *Six Salmon Rivers and Another* depicts life along the river.

"One afternoon, about the year 1838, my grandfather decided to pole his pine dugout canoe the seven miles to the village of Blackville for some needed supplies, and grandmother expressed the desire to go with him. Their first child, a boy, was then only eight months old, so he was carried to the shore in his small wooden cradle, which was set in the middle of the canoe. Then my grandmother got in, and once she was seated, grandfather followed, picked up his setting pole, and he began poling up the swift current.

It was late in the evening before they had finished shopping and visiting, and began the return journey to White Rapids. Before long, darkness settled over the river and the surrounding hills. Then grandfather drew in to shore and filled an iron basket - called a noggin - with pitch-pine which he lighted, and suspended it on an iron crane over the bow of the canoe. Grandmother took his place in the stern, and guid-

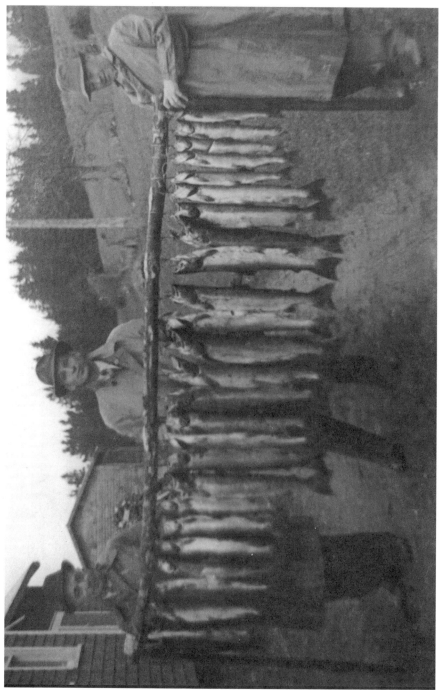

Left: Major Wells Middle: Dr. Hawkins Right: Jack Sullivan

ed the craft down the river, while he stood upright in the bow, back of the flare, his long-handled salmon spear poised for action.

The flambeau cast its golden circle over the water, which was alive with a late run of salmon on their way to the spawning bars on the upper reaches of the river. The light attracted rather than alarmed them. For an expert such as my grandfather it was quite a simple task to take them one after another, throwing them behind him in the bottom of the canoe. He speared fifty great salmon that night, and only stopped taking more at my grandmother's stern command after one of the fish rolled over into the cradle and awakened the sleeping baby.

Yes - the Miramichi was a great salmon river six-score years ago. Often the settlers took so many during the spring, summer and autumn runs, that some were used to fertilize the land. It is still a great salmon river."

• • • • •

Jack Fenety was born March 22, 1920 at Fredericton. Jack was a Fredericton school system boy who aspired to become a forester and attend the University of New Brunswick. Like many other young men his age Jack joined the army. Luck was not on his side as he incurred a serious back injury and his dream of working in the woods was curtailed. However, Jack's affinity for the outdoors instilled by his father John G. Fenety, a Provincial land surveyor, remained with him throughout his lifetime. With Jack's love of the woods and waters - the deer, the trout, the partridge and salmon and so on - conservation and preservation became lifelong goals.

In September, 1945, while shopping for his government authorized suit at Flemmings' Clothing Store, Jack ran into an old friend Malcolm Neill. This conversation led to a job for Jack as a radio announcer at C.F.N.B. from October 1945 until Jack signed off on January 31st, 1988. The program most associated with Jack is "Fact and Fancy" which was listened to by tens of thousands of listeners from Maine to Newfoundland.

In 1953 the Atlantic Salmon runs on the mighty Miramichi were probably at an all time low despite the fact it was supposed to be the "mother of all rivers." There were few large fish and the grilse were only coming up in the fall. This was a very, very precarious period in

time. There were a number of outfitters on the river - the Clayton Stewarts, the Tom Boyds, the Charlie Wades, the Swazeys etc. As well, there were a number of concerned Americans who owned waters and camps or just enjoyed fishing our waters as sports as well as many concerned anglers and guides.

A meeting was called to assess the situation and The Miramichi Salmon Association was the end product. By September 1953 the group became incorporated. Malcolm Neill who had a vested interest as proprietor of Neill's Sporting Goods Store became one of the directors. At the October meeting Malcolm persuaded Jack to join him at the meeting. An interesting situation occurred as the members were going to pass some type of motion. Jack got into a wrangle with a gentleman by the name of Clemmy Ford. Jack said that if any motion was going to be passed at least the members should have been notified in advance. The old gentleman, not a very tall man with snowy white hair, walked over and said, "consider yourself as being notified." Jack was initiated into the MSA.

Jack Fenety's name is synonymous with the Miramichi River and the Atlantic salmon around the world. In 1959 he had become a director of the MSA and in 1961 President, a position he occupied until September 1996 when Bud Bird took over. Because of his lengthy tenure he was often deemed President for life. Jack often stated to friends that when he retired he would spend less time working and more time fishing. This was not the case, as Jack states,

"The Salmon business is a 365 day a year job and the perimeters just keep widening; the battle is never won. It's two steps forward and four steps backward."

There isn't a New Brunswicker who has sacrificed as much energy and time towards the survival of *salmo solar*. Jack has been a man of action with a vision for the future. For four decades of trials and tribulations Jack has persevered. He has been a key player in calling for a halt to pollution by major industries as well as lobbying successfully against the government's spraying of the deadly substance DDT which was killing trout, salmon and other wildlife in the 60's.

Over the years Jack has locked horns with some in the native community over his insistence on a total ban on gill netting. Fenety advocates trap netting as an alternative. Chief Steve Sacobie fondly referred to Jack as another "General Custer."

Jack's group, the Miramichi Salmon Association, was instrumental in having uniformed wardens patrolling the river. The MSA also implemented an education program in the schools so the students would learn to know the difference between salmon parr and trout, among other things.

Fenety has stood toe to toe with politicians on salmon-related issues even going so far as advocating the resignation of then fisheries minister, Romeo LeBlanc (1982), when Ottawa refused to listen to reason. Jack was instrumental in securing a buy-out of the commercial fisherman in New Brunswick and Newfoundland.

Projects like satellite rearing and river management have all taken place with Jack's approval. He has been regarded by some as being the Dean of the Miramichi for his wisdom. Joseph F. Cullman, 3rd, once remarked about Jack Fenety in regards to salmon fishing, "When Jack Fenety has spoken, is there anything left to say."

Over the years Fenety has garnered numerous awards for his leadership in the restoration of the Atlantic Salmon including the T.B. Fraser conservation award, the Governor General's Commemorative Medal, the Canada Recreation Fisheries Medal and an honorary doctorate from the University of New Brunswick, along with many other distinctions.

Hats off to Jack Fenety for a job well done. If salmon continue to ascend and spawn in our rivers we in New Brunswick owe a debt of gratitude to Jack. The Atlantic salmon has a great champion in the person of Jack Fenety.

The following information is from a letter written by Jack:

Peter,

"Here are some off the cuff remarks about my views for the future of the Atlantic salmon. That some of my material may be disputed is to be expected, but I remain firm in my beliefs. And too, there are any number of other matters which affect the salmon and that I have not mentioned here. However, should my points be largely enshrined then the Atlantic salmon will stand a good chance for survival."

Jack's Vision For the Future:

The future which lies ahead for the Atlantic salmon will, in large measure, depend upon the type of politicians the people of the various salmon-producing countries elect.

There will be others having a say in what types of policy and regulations will apply to future salmon runs. But, it will, in the final analysis, be the politicians who will set the pace and write the overall programs that will decide the salmon's future.

What do I think the future of the Atlantic salmon might be? . . . Well, I can, like most other people, only hazard a guess. Some people make better guesses than others, but no one individual can forever be right. Some will have educated guesses. Some will guess solely upon what their heart tells them. While others will just plain guess!

This is how I see the salmon's future, based of course upon the salmon world's population of electors making the best possible selection of policy makers and administrators.

Controls must be placed on pollution for all waterways and oceans.

All commercial salmon fishing must be eliminated.

The use of gill nets must be banned around the world.

Our salmon runs must be administered upon a river-by-river basis.

Local authorities must have the right to decide policy for their rivers.

All salmon farms must employ steel netting cages. Current escape levels are too high. World standards must be put in place for salmon farming in the seas.

When all, or the majority of the above items, have been placed into law, then the chances for improved Atlantic salmon survival will at the very least be greatly enhanced.

I believe that no one country can by itself resolve the current salmon problems, but if all salmon producing nations act in common, then and only then, will the salmon's survival be assured.

Although the world presently has hundreds of thousands of interested salmon conservationists, their numbers pale in the general population of the world which largely couldn't care less about the salmon or any one of a thousand different other species being threatened in our

oceans and rivers. Wider public support for conservation, while highly desirable, just won't happen. It is the governments of the world, especially those who raise salmon, that must provide the ways and means toward active, regulated salmon control. The much desired programs for Atlantic salmon enhancement can only be obtained through world wide co-operation of the governments most effected. Although Canada has recently taken some very widely welcomed steps toward conservation, our record until now has been a rather dismal affair. Politics has largely been the determining factor in the majority of Canada's decisions relating to the Atlantic salmon. Millions of dollars have been spent, but additional millions of dollars will be required in the future. Let us all hope that actions taken here at home and in all affected countries won't be too late."

Marjory Rogers Donaldson

Marjory Rogers Donaldson was born in Woodstock, N.B. in 1926 and currently resides in Fredericton, N.B. She studied art at Mount Allison University (BFA, 1951, working mainly with Alex Colville and Lawren Harris Jr.) and at the City and Guilds of London Art School in England in 1963-64.

Solo exhibitions of her paintings and drawings (principally of flowers and nudes) have been shown in public and private galleries in the Atlantic provinces. She has drawn all of the charcoal portraits in the New Brunswick Sports Hall of Fame - 150 approximately to date. Marjory also has had a long connection with the University of New Brunswick Art Centre, serving as director from 1986-1991.

Morning Has Broken

It's the bewitching hour of the day. As I await the sun's first morning rays, I'm elated to be part of it. I'm seated on a rock garbed in fishing gear, waiting - waiting to angle for salmon at my favourite pool - The Dunbar on the Nashwaak River.

It's the dawning of a new day heavy with a sense of eeriness as the shadowy images of the night transform to grey dawn. The creatures of the night are returning to their burrows, nests and dens seeking refuge. Few humans will ever know the dramas played out throughout the night.

The air is motionless - perfectly calm with a fresh pine smell that you can almost taste.

A stone's throw away an early bird opens its eyes, then rises and drifts through the air landing on its favourite perch - a 200 year old white pine which has borne witness to many events over the years. From this perch his piercing eyes scour in all directions, and then he begins his morning serenade. The song is complicated, rising then falling in melodic overtones, a language that is incomprehensible both in form and in range to the human ear. A bat flitters overhead foraging for her last morsels before embarking on her homeward journey.

There is a moment in eternity when one can view the layers of darkness disappearing, like a curtain being drawn slowly open to reveal the lighter shade of an image that is forever changing, mysteriously never

the same. The colours of the vegetation are yet to be defined, the shading subtly out of focus. The ball of fire is not yet on the horizon but the whole of the eastern sky whispers of golden rays while overhead the last of the night's galaxy slowly disappears. It is such a mystical transformation.

And then just for a moment, there is a hush, almost as though mother earth were holding her breath. The first rays of sunlight allow me to distinguish the shapes and forms of the stately trees that line the shore.

I hear some splashing nearby. There's some type of animal crossing the river. I squint my eyes into focus, barely able to identify a white-tailed deer meandering across paying no attention to my presence.

I realize that a million-trillion living things shift imperceptibly from their night's repose to greet the morning glory. Flower petals open, leaves and grass shift position jostling for the best place, the disposition of old Mr. Sun playing no favourites. Nature comes alive in a perfect synchronicity.

I glance attentively over the rippling waters and catch a glimpse of Silversides breaking the surface. I amble to the top of the run realizing that I am such a small part of God's universe.

David McKay

David McKay has been painting on a full-time basis since 1972. He has been included in exhibitions that have toured Canada and abroad. He exhibits regularly in galleries in the Maritime Provinces, Ontario and Alberta. David's paintings can be found in many private collections including that of the Irving family as well as His Royal Highness Prince Andrew's at Buckingham Palace.

Big Fred Fowler

Songwriter: Alden MacKay
Recorded by: Mavis (MacKay) O'Donnell
"Hats Off to the Miramichi"
Date Written: 1974

I must have played that song a hundred times at Reid's Restaurant in Boiestown.

The stop was like a ritual, to get a bite to eat and listen to a few tunes on the juke box.

I don't know what is so magical or whimsical about the song - it just kind of grows on you. Personally I could vision a well-tanned guide who knew just about all there was to fishin', polin' and guidin'. The song is a great tribute to Fred whom I finally met in 1997.

He's the man from the Miramichi
He's the man from Holtville, NB
He's the one who's in demand
Big Fred Fowler is a guidin' man

He paddles and poles a canvas canoe
Up and down the waters blue
Big strong muscles and calloused hands
Gotta catch a fish for the old sport man

You should see him snub that canoe
You should see him shove 'er to
There's no such thing as "push 'an be damned"
When big Fred Fowler is the guidin' man

Chorus:

He knows every ripple and he knows every rock
He knows where to anchor and he knows where not
He's fished these waters and roamed the land
Big Fred Fowler is a guidin' man

He shows 'em where to fish; he shows 'em where to cast
Tells him stories of days gone past
Big Fred's face is a brown, brown tan
From the sun and the wind, he's a guidin' man

He shows 'em what to do when the salmon strikes
Shows 'em what to do when the salmon fights
Gotta get that fish onto dry land
And prove himself a friend to the old sportman

He weighs that fish and he jumps all around
For he'll go over twenty-one pound
Can he catch another, you bet he can
Big Fred Fowler is a guidin' man

Repeat Chorus:

Well he knows how to fish and he knows how to cook
He's the best there is around Rocky Brook
He boils that tea in an old tin can
And serves the grub to the old sport man

He heads for camp when the day is out
With a salmon and a grilse and a three pound trout
There's a twenty dollar bill held tight in his hand
That's the tip from the old sport man

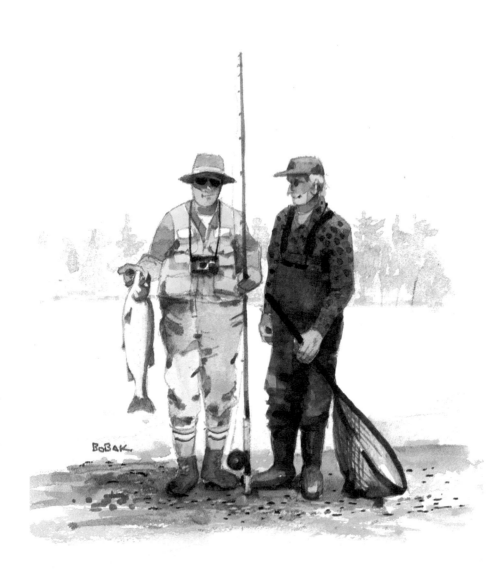

He'll go home on Saturday night
His wife, and kids, will hug him tight
He'll hug them back just as long as he can
'Cause he's got the lovin' heart of a guidin' man.

Stories By Bill Wyton

Bill was born in Birmingham, England in 1907. He and his family settled in Taymouth on May 27, 1920. Bill worked at various jobs including the log drive, lumbering and eventually he and his wife Nellie became farmers on 365 acres on the Nashwaak by MacBean Brook. They raised a family of 7 children, 6 of whom were all born in his house. One of his girls, Sheila, was even born without a doctor, just a mid-wife.

Bill's types of stories could be told by many New Brunswick men and women who grew up in the 1920's, 30's, and 40's. He had the uncanny ability of telling stories that happened years ago as if it were yesterday.

• • • • •

Fishin' for Trout

When I was a young fellah Mum used to send me down to the MacBean Brook to catch a few trout for supper. I used to go down and sit on a little pier. I would dangle my line with worms for bait and there would be no trouble to catch a half-dozen to a dozen trout at 9, 10, and 12 inches. Nobody else fished it. People back then didn't have the time to fish. They had to keep their nose to the grindstone.

Bigmouth *Michiel Oudemans*

One day I was down in the field fishin' and caught a 16 inch trout. That was the biggest one in my lifetime. I seen it layin' there under a log, ya see. Well I tried bugs, flies, caterpillars, worms, a grasshopper - everything. At last I shook my head, ready to give up. I could still see the tail of the trout going back and forth beside the dead-head on the bottom of the stream.

I decided I'd give her one last try. I had a nice red shirt on. I took my jack-knife out, cut a piece off it and snapped it on a hook. POW - Papa Speckles took it and I pulled him to shore. That was the nicest trout I ever caught.

Michiel Oudemans

Michiel is well known in New Brunswick and abroad as an excellent printmaker and book artist. He has recently returned from Holland where he held a solo exhibition. Michiel is represented at the N.B. Art Bank, at numerous other institutions and in private collections.

• • • • •

The Peddlar

We used to get a lot of peddlers stop by the house. We used to call them by different names. One fellah in particular comes to mind. His name was Abraham Ramey. We called him Father Ramey because he was from the holy land - Lebanon. He was a well educated man. Mrs. Moosie, his wife also peddled mostly around the Fredericton, Marysville, Minto area. Her real name was Sadie but the customers knick-named her Mrs. Moosie.

Father Ramey used to go through here with a horse and wagon with a box on the back. Down the back end there was two doors with a padlock on it. There were shelves on it and he carried everything from candy to women's panties - we called them knickers or drawers in those days. He had shirts, underwear, pants, overalls, buttons, threads, needles, ribbons - everything like that.

He used to start in "Freddy" and go all the way to Newcastle. He owned the Ramey block at the Corner of Queen and Westmorland Streets in Fredericton.

Many times Father Ramey would spend the night at our place. I used to tend his horses and feed him. He always told my wife that she could pick anything that she wanted without payin' for it. We never did. She knew that the old fellah wouldn't be doin' that just for fun - travellin' by horse and wagon to Newcastle.

The last time he came I remember clear as day. He said, "this is my last trip. I want to thank you for your kindness and generosity because soon I'm going to the holy land" - he meant heaven, ya know.

· · · · ·

Livin' Off the Land

I grew up on a 360 acre farm beside MacBean Brook. We were practically self-sufficient. We had very little "boughten stuff" as they called it. We had 12 or 13 cows - 5 horses - 30-40 sheep - hens, geese and pigs. As a family we all worked extremely hard. I think that one of the problems with some of the kids today is that they don't know what it is like to do a good day's work.

In the fall Dad and I used to shoot deer and moose to feed the family. It was also the time of the year to kill the pigs. We'd fill a wooden barrel partially with brine and put the pork in it. Then we'd place two flat rocks on top. That'd hold the ham down so it would cure. We'd hang the beef and other meat in the woodshed. Mum or Dad would cut off what we needed for suppers with a meat saw.

We never knew what a clothes washer or dryer was - everything was washed by hand with a scrub-board and hung out to dry on the clothes-line.

Every year we would have a nice garden with lots of vegetables many of which were stored in the root cellar for winter time.

Grandmother lived with us and she would spin the wool from the sheep into yarn and make socks and mittens and all of our underwear. Talk about itchin' and burnin'!

Every now and then Dad would announce,

"Tomorrow mornin' we'll be headin' for town to do some business."

I used to go with Dad and we'd leave at 2 a.m. in the mornin'. We'd harness the team of horses and put a little hay and blankets on the bottom of the wagon. Generally there'd be 30-40 pounds of butter-brown prints, 10-12 dozen eggs, maybe a ham or whatever else we might have at the time.

We'd jaunt along Killarney Road and four hours later we'd arrive on Queen Street. Back then we could stable the horses for two-bits and feed them oats for another two-bits.

We'd either barter or sell our wares for such things as a barrel of oil, a box of crackers, a keg of molasses, a barrel of flour (cream of wheat) - no luxuries just the essentials.

Around dinner time Dad and I would go to the Westmorland Hotel. Talk about vittles - all you could eat for 35 cents - ten pieces of pie if you wanted it.

I miss the good old days. Things are sure different today.

Cheryl Bogart

Cheryl Bogart was born in McAdam and currently resides in Jemseg, N.B. Since turning professional in 1982 her paintings have been exhibited in Canada and abroad. Her works reflect a fascination with relationships and humanity at all stages of development and experience.

Today her paintings are in the permanent collection of the Canada Council Art Bank in Ottawa, the Art Gallery at the University of Moncton and in private collections in Canada and Europe.
Cheryl has won on two occasions recognition in the Marion McCain Art Competition.

The Legacy of "Kid" McCoy

Albert McCoy was born June 6, 1878 in Birmingham, England. He came to Canada as a young boy as part of the group known as the "home children" aboard an old sail boat named the *Bluenose*. It was the MacCandlis family who formally adopted Albert and allowed him to keep his last name.

Albert grew up on the outskirts of Fredericton (Richibucto Road) working on the farm and in the woods. He developed into a short but powerful man at 5 feet, 8 inches, tipping the scales at 200 pounds. It was nothing for him to walk 12 miles to Carlisle Road - cut one to two cords of wood with a double-bit axe and then make his way home. When Albert was courting his wife to be, Elizabeth Curtis, he'd cycle, using his balloon-tire bicycle, approximately 100 miles from the Richibucto Road to Grey Rapids in a day.

Feats of his strength were well-known. Albert would lift the front-end of a Ford Model T with two men on either side spinning the wheels. He once lifted the front side of a 2 ton truck so an Eaton's catalogue could be slid under. When he went to town to buy oats he'd show off a bit carrying a hundred pound bag under each arm and another with his teeth.

As he grew older word spread far and wide about his enormous strength, his fighting ability and his accuracy in shooting. Word on the street was that Albert was "strong as an ox" - could "whip his weight

45

in wild-cats" - and was a crack-shot capable of breaking a button the size of a 5 cent piece from 75 yards with his 300 Savage rifle.

On one occasion three men from outside the community challenged Albert and he whooped all three at once. On another occasion a whole family stopped by the house with the idea of beating the tar out of him. Albert told the challengers that he'd take any two at once in fisticuffs or the whole bunch with his shot-gun. Needless to say, they made a hasty retreat. He was a bit like Paul Bunyan and Davy Crockett rolled into one.

Don McCoy recounts how his father earned the nickname ("Kid"). "Dad was keeping an eye on Lindsay's Restaurant at the hotel one night. This fellow was harassing a couple of the women. Dad told him to keep to his own table and mind his business. The man who was a professional boxer wanted to know if Dad wanted to make something of it. Well, they came to blows and Dad finished him off pretty quick, breaking his jaw and putting the man in hospital. From then on everyone called him Kid McCoy after the fighter (Kid McCoy from the late 1800s). You can imagine how fast word spread via the grapevine in the community.

Perhaps the story which has made the "kid" infamous and has become a saga in New Brunswick woods occurred on a November day, 1909. This story has been told and retold thousands of times in hunting lodges, around camp fires and in lumber camps.

On a November day Andy and Will Lindsay accompanied by their guide Kid McCoy, arrived at the bull pasture not far from the Burpee Stream on the Richibucto Road. Today the area is a game refuge enclosed by the Acadia Experimental Forest Reserve. It is still a common gathering place for moose.

Andy and the Kid were scouring the area together and Will went on his own. The duo came to a clearing where they spotted five moose - one of which had a 22 point set of antlers and weighed well over 1500 pounds. The Kid motioned for Andy to take the largest bull moose. Andy fired his single shot, only wounding the magnificent animal. The Monarch bellowed, pawed the ground, ready to charge Andy who was the closest. Meanwhile the "Kid" took dead aim and fired - nothing. His gun misfired.

The "King of the Woods" began the charge. The Kid armed with his rifle reacted on instinct and stopped the moose from killing or maiming his friend. The antlers ripped at the Kid's coat and the plunging hooves just missed his body. The Kid wasn't about to back down from the biggest challenge of his lifetime. He stood toe to toe sparring with the wounded animal with his rifle. Andy had wisely made his way behind a tree nearby and the Kid wasn't far behind as the rifle broke in two. The moose retreated and was getting ready for a new charge pawing the ground with blood-shot eyes and nostrils frothing in anger.

Out of the blue appeared Will Lindsay who took dead aim and shot the "bull of the woods" which fatally landed beside the frightened man.

Albert (Kid) McCoy and his wife Elizabeth raised a family of five boys and six girls. He died on December 26, 1964 at the ripe old age of 86.

The Revival Meeting

Told by Flora Clayton

This happened when Charlie Sr. was in his late teens. Around 1922 Charlie went hunting miles back in the woods and unfortunately met up with a skunk which sprayed him. He said that he heard a rustling sound in the bushes, peeked in and saw this green spray coming towards his face. It got him good, in both eyes, and he was temporarily blinded. He laid his gun down so he would wipe his eyes as they were very painful. He did not know what was going to happen and he could not find his way home. No one knew exactly where he was and it would be the next day before anyone would start searching for him. Poor Charlie put in some miserable hours before his sight began to return. He made his way to a small brook and bathed his eyes and soon his sight was good enough for him to find his way home.

It was after the supper hour when Charlie reached the house, but there was no one at home to greet him. There were revival meetings being held here in the church and the family had already left for the evening service.

He got some of his Mother's homemade lye soap, shampooed and bathed using several changes of water, and put on fresh clothes. After eating his supper, he went outside to have a smoke and then he noticed he could no longer smell the skunk odor - he had lost his sense of smell and did not know it.

A long evening stretched ahead. Now that there was no skunk odour he decided to walk down to the church, probably too late for the service but at least he could walk back with the boys.

When Charlie arrived the service was about half over and every head was bowed in prayer so he slipped quietly into the back of the church. The prayer lasted a long time and by the time it was over there was a strong skunk odour inside the church. The building was packed with people and it being a warm summer evening the door and windows were open. One man jumped up and closed the door and those who were sitting by the windows closed them.

Now, picture the scene. We have a warm evening, hot inside the church, door and windows closed, and the skunk odour getting stronger by the minute. Some thought for sure there was a skunk loose in the church. The air was getting so heavy it was difficult to breathe. The minister gave the Benediction and every one made a run for the door. Charlie was right beside the door so he was the first one out. He was wondering why everyone was in such a mad rush!

When Charlie joined the people who were walking up the road, they very quickly found where the skunk odour had come from. He had walked down alone and the people made him walk back alone, a good ways behind them. This was the one and only time Charlie Clayton Sr. closed a Revival Meeting.

Neil Moffatt

Neil Moffatt is a Fredericton resident and a graphic designer and sign maker. As a hobby he draws cartoons – many published in provincial editorial pages. Neil has a great respect for the 'old-timers' who by their acts and deeds have added to the folklore that is found within this book.

The following poems, relating notable incidents from the past, were found in Lawrence Van Horne's attic and are presented here unedited. The three following poems were written by George Rainsford who in the 1920s and 30s peddled them door-to-door for the modest sum of 15 cents apiece.

The Murder at Benton Ridge
Committed by Benny Swim

Benny Swimm was born on the Mainstream near Woodstock in 1900. The story of his being hanged twice has long been a subject of controversy.

Benny grew up in an impoverished environment with the philosophy of "might is right" and "an eye for an eye". He fell in love with his cousin Olive Swimm and had a relationship. When Olive left to move in with her new lover, Harvey Trentholme, Benny planned and executed an act of revenge.

> Come all young men and I'll tell you
> Of a wrong that was did to me.
> By a man named Harvey Tremholme
> And a girl who was engaged to me.
> My parents they call me Benny Swim,
> I was born on the mainstream,
> It was there I spent my childhood days
> Where I used to sit and dream.

To-day I am lying in a cell
Up in the Woodstock jail,
Thinking of the deed I've done
And no one to go my bail.
My age is twenty-two boys
And that you all know well,
Brought up by honest parents
The truth to you, I'll tell.

I was walking along the road one day,
This story to you I will tell,
I met a man they call John Swim
Who'd lead any soul to Hell;
We walked along both arm in arm
When John Swim said to me -
Step into my neighbor's house, Benny,
And have a talk with me.

You can have my daughter, Olive, Benny
To do with what you like,
If you will get your sister
To come and be my wife.
His daughter Olive was handsome

With a dark and rolling eye,
I promised for to marry her
And that I'll not deny.

We lived together for fourteen months,
Before our wedding, one day
She fell in love with another man
And then she ran away,
She ran away to Benton Ridge,
At her father's home she did stay,
To live with Harvey Tremholme
Until their wedding day.

When this young man Benny Swim,
Found out what Olive did,

He said, I'll go and see her
In her home at Benton Ridge.
I loved this girl with all my heart,
This girl named Olive Swim,
I would lay down my life for her
Was the words of Benny Swim.

In the year 1922,
On the 27th day of March,
I left my home and parents
Not thinking of turning back;
The gun was in my pocket
And my thoughts were far away,
Of the wrong this girl did to me
And the man who stole her away.

When I met this girl Olive,
She was fairer than the rose on the tree
She was a maiden of eighteen summers
When she promised to marry me.
I went up to her cottage,
She being a bride of two weeks,
And I said to Harvey Tremholme
To Olive Swim I would like to speak.

I asked her for the engagement ring
I had bought for her one day,
And also my mother's wedding ring
She had borrowed for her game of play,
Olive dear listen to me
For I haven't long to stay,
Kindly give me back my rings,
And I will be on my way.

Harvey Tremholme he then got mad,
He rolled up his sleeves and swore -
Benny Swim do you see that road?
Take it and come no more.
I pulled my gun and shot him,

The bullet going through his head,
He fell then in front of me
Across the doorstep dead.

And when he fell in front of me
My mind seemed all a blank,
I fired a shot at Tremholme's wife
And down on her knees she sank;
Arising to her feet again

She walked through the front room door,
I shot her again through the back
Then she fell on the floor.

Down upon my knees I went,
I saw that she was dead,
I ran out to the hen house
And shot myself through the head,
And when I saw I didn't fall
I to myself did say,
It was better to get away from here,
And I started on my way.

I walked seven long weary miles,
It was there I went to bed,
And all that night, the girl I shot
Was rambling through my head,
Atwisting and aturning
No rest could I find,
For the gates of Hell wide open
Before my eyes to shine.

Come all you brave young country lads,
A warning take from me,
Never to murder the girl you love
Whoever she may be,
For if you do, you'll surely ruin
And find yourself like me,
And die a public scandal
Upon the gallows tree.

Tragedy in New Brunswick 50 Years Ago

October 21st, 1871

Scandals involving misplaced love and adultery are not unique to today. In fact the human race has always been subject to the weaknesses of the flesh. The nineteenth century was no exception, in spite of the pristine image we usually have of our Victorian ancestors. John A. Monroe, drawing from his own horrendous experience in 1871, issues a stern warning to any who would take heed.

Come all my fellow citizens
　　　And lend to me an ear,
A mournful revelation
　　　You presently shall hear,
Concerning a young female
　　　Who in Carleton did dwell,
She was handsome and innocent,
　　　The truth to you I'll tell.

When first I met young Sarah Vail,
　　　'Twas on a picnic day,
We were introduced and pleasantly
　　　We passed the time away;
Not knowing I was married
　　　And trusting me also,
Little did she ever think
　　　I'd prove her overthrow.

It was for a year and better
　　　I kept her company,
My wife was little dreaming
　　　Of my inconstancy,
Until a child she had by me
　　　Which set my brain on fire,
And for to take her previous life
　　　It was my whole desire.

Likewise five hundred dollars
 She intrusted to my care,
She said no living mortal
 With me she could compare;
Alas, how far mistaken,
 And how little did she dream
That I to take her precious life
 Had laid a treacherous scheme,

It was on a trip to Fredericton,
 I this horrid scheme did lay,
That in some dark lonesome place
 I'd take her life away;
In a boarding school called Lordley's,
 She took up her abode,
It was from there I asked her out
 To the Black River road.

On the thirty-first day of October
 In the year of sixth-eight,
Sarah Vail and her infant child
 They met a horrible fate;
I had a coach all ready
 To come at my command,
To take us out to Bunker's,
 As you shall understand.

We left the coach at Bunker's,
 And journeyed on with speed,
Until we came unto the spot
 Where I meant to do the deed;
We stepped aside from off the road,
 And sat down on a stone,
And looking around on every side,
 I found we were alone.

The child it then began to cry,
 Which made my anger rise,

I quickly seized it by the throat
 All for to stop its cries,
The mother arose to save her child,
 But I had choked it dead,
And with a loaded pistol
 I shot her through the head.

After I had done the deed,
 My heart did not relent,
For Satan worked so hard in me
 That I could not repent;
With moss and brush I covered them,
 And left them to decay,
And then unto the city
 I quickly took my way.

Scarce a year had passed away,
 The time did quickly fly,
Some colored folks were berrying,
 A human skull did spy;
The news was quickly spread abroad,
 The rumour soon went around,
And many went to view the spot
 Where human bones were found.

Some of the noted doctors
 Were summoned to the place,
Likewise the coroner of St. John
 To analize the case;
The bones they were examined,
 And quickly it was shown
That murder was committed there,
 By parties then unknown.

The coachman gave his evidence,
 Suspicion fell on me,
And soon I was arrested,
 As you shall plainly see;

Witnesses were soon gathered -
 Sisters of Miss Vail,
Things went so hard against me
 That I was sent to jail.

There I lay with troubled mind
 Until my trial day,
The judge he passed my sentence,
 These words to me did say:
"On the fifteenth day of February,
 You will by the neck be hung,
May the Lord have mercy on your soul,
 For the awful deed you have done."

On the fifteenth day of February,
 I take my last farewell,
Of all my companions
 That in the town doth dwell,
Likewise my loving help-meet,
 And her two children small,
When I think of parting with them,
 It grieves me most of all.

Let all who read this history,
 A warning take by me,
And shun the paths of sin and death,
 Likewise bad company;
And all young men and maidens,
 A warning take also,
And shun the fate before too late,
 Of John A. Monroe.

Halifax In Ruins

The Halifax Explosion goes on record as being the most powerful and disastrous man-made cataclysm in history prior to the atomic bomb and the greatest disaster ever to strike a Canadian city The devastation and loss of lives proved to be a tremendous blow to the "warden of the North" and inspired many a tale, including the following poem by George Rainsford.

It was on the sixth of December,
 Nineteen hundred and seventeen,
That Halifax suffered disaster
 The worst she'd ever seen.

The morning was bright with sunshine
 'Twas a typical winter day,
None had a thought of danger,
 As they wandered their busy way.

The children had gone to their lessons,
 Their mothers were busy at home,
While father worked on in the factory
 Little dreaming he'd soon be alone.

There comes creeping up the Harbour
 A ship loaded down to the rail,
With the most horrible death-dealing cargo
 That was ever allowed to sail.

She carried a deck-load of Benzol
 And shells for overseas,
In her hold a new explosive
 They call it 'T.N.T.'

Now why should this death-dealing monster
 Be allowed to come creeping in here,
To bathe our beautiful city
 In widows' and orphans' tear?

There comes a cry from a merchant
 There's a vessel a-fire out there,
But a few pay any attention
 For that is the firemen's care.

The relief ship had rammed the monster,
 Tearing a hole in her side,
And then eased out in the stream again,
 And drifted on with the tide.

It was five minutes after nine,
 As those still alive can tell;
That the beautiful city of Halifax,
 Was just given a taste of "H-ll."

The earthquake has its rumble,
 The cannon hath its roar
But this was worse than even those
 Yes, multiplied by four.

And then when the crash was over
 Those still alive struck dumb,
Turned into living statues,
 Wondering what next would come.

For no one knew what had happened;
 Some thought it the end of the world,
While others surely thought 'twas the Germans,
 Marching in with their banners unfurled.

Then rushing out into the streets,
 From their tumbling and shattered homes
Some with cuts and bruises,
 And others with broken bones.

They were met with a sight more horrible
 Than any they'd ever seen,
For there lay the dead and dying -
 It was worse than a battle scene.

Houses were crushed like paper,
 People were killed like flies,
The coroners record tells us
 The toll was twelve hundred lives.

Two thousand were maimed and wounded,
 Hundreds will lose their sight,
And God knows how many children
 Were alone in the world that night.

From north to "Rockhead" hospital,
 And west to the Exhibition grounds
There wasn't anything living
 And not a single sound.

The streets were filled with debris
 With dying and with dead,
There lies a little baby hand,
 And there an old man's head.

There out upon the "Commons,"
 That cold December morn
Tender, innocent little souls
 Into the world were born.

Women hugged their children
 Their hearts were filled with fear,
While husbands lay beneath their homes
 They all had loved so dear.

(Old) Time went on apace,
 Chill night was drawing nigh,
And many were those whose roof that night.
 Was just the bright blue sky.

And then the following morning,
 As if to hurt them twice
There came a storm from the ocean -
 A blizzard of snow and ice.

Freezing the poor unfortunates
 Who had no place to go
And many a poor soul drifted
 To Heaven from out the snow.

The 'States' weep with you Halifax,
 In this your hour of sorrow,
They offer you their help and gold,
 So don't wait till to-morrow.

Just wade right in and help yourself,
 And we the bill will pay,
For that's the way they do things,
 In Canada, England and U.S.A.

Clive Roberts

Clive Roberts joined the Royal Canadian Air Force at an early age and served abroad in the countries of England and India. Upon returning home in Argyle, Nova Scotia Clive pursued his dream of teaching art by attending Mount Allison University.

He came to work in the Fredericton area in 1952 as "Supervisor of Art" for the school board. Later on in his career he was appointed "Co-ordinator of Art" for School District #26.

He has been painting, mostly in watercolour, since his retirement in 1981. His pictures are in the N.B. Art Bank, the Canada Council Art Bank and private collections worldwide. He is represented by the sign of the Whale Gallery in Yarmouth, N.S. and Gallery 78 in Fredericton.

Malabeam

The story of Malabeam took place well over 500 years ago at Grand Falls, New Brunswick. Malabeam was responsible for saving her Maliseet Village from an attacking party of Mohawk warriors. Although she sacrificed her life and her body was never recovered, she is still remembered by her people as a heroine. A plaque at the Grand Falls Tourism Office gives the reader a fleeting, intriging glimpse into the legend which has been passed down from generation to generation, in a poem by W.D. Kearney.

The Maiden's Sacrifice

In the sweet days of summer five hundred years ago,
The broad swift Wigoudi flowed on in might below,
On rushed the ceaseless torrent, which down the great Falls bore,
Over the steep, with sudden leap, full eighty feet or more.

There on the bank, above it, an Indian town arose.
Where dwelt the war-like Maliseets, the Mohawks were their foes,
The red skinned sons of slaughter had joined in many a fray,
With savage ire and carnage dire shaming the light of day.

But buried was the hatchet, they went to war no more,
The little children gambolled about each wigman floor,
Around each savage village were maize fields waving green,
Mid such a sweet peace one scarce knew that war had ever been.

Sacobie and his daughter, the dark Malabeam,
Sailed up the Wigoudi, beyond the Quisibis stream,
And there upon an island, they rested for a day,
Their hearts were light, the world was bright, nature's face was gay.

But like a clap of thunder when the heavens are calm and clear,
The warhoops of the Mohawks fell on their startled ears,
And a sharp flint-tipped arrow pierced old Sacobie's breast,
Ere Malabeam could raise him, her father was at rest.

And bounding through the thicket, on rushed a savage crowd,
Of Mohawks in their war-paints, with war-hoops fierce and loud,
And 'ere the orphan maiden had no time to turn to fly,
They bound her fast, all hope was past, except the hope to die.

But one who knew her language said: "As soon as the sun goes down,
Your bark canoe shall guide us to your father's town,
Do this your life is spared, then you wed a Mohawk brave,
Refuse, your doom is torture, or worse, to be a slave.

Then she said: "I will guide you and wed a Mohawk brave,
Though you have slain my father, I need not be a slave,
The stream is swift and broken and those apart may stray,
Keep your canoes together and I will lead the way".

There by her slaughtered father, the weary hours she passed,
Till the sun went down and the lofty trees a gloomy shadow cast,
Thinking of home and kindred, of the friends she could not warn,
The murderous night and the gory sight would greet the morrow morn

Just as the gloom of dreariness spread over hill and dale,
Down the swift Wigoudi the Mohawk fleet set sail,
Three hundred Mohawk warriors chanting a martial song,
Their paddles gleam upon the stream as swift as they move along.

In four long lines together, each to the next bound fast,
The Maiden in the center, the great canoe fleet passed,
And he who knew her language, a line of silver drew,
As he bent to the forward paddle of the Maiden's birch canoe.

CLAUDE ROUSSEL 46

The song was done and silence fell upon every tongue,
On warriors, old and grizzled, brave, untaught and young,
Hate filled each swarthy bosom, nearing the thrice doomed town,
Flow on, O mighty river, and bear the foemen down.

But little cared the Mohawks, the wind might wail or sigh,
The moon might hide her glory and clouds obscure the sky,
With hearts intent on laughter, with thoughts on carnage fed,
They toiled, and still before them the strong-armed maiden sped.

And now the Indian village lies but a mile below,
A sound like muffled thunder seems on their ears to grow.
What's that? "Tis but a torrent," the Indian maiden replied.
"It joins the strong Wigoudi which here flows deep and wide.

Speed on a little further, the town is now hard by,
Your toils are nearly over and night still veils the sky,
The town is wrapt in slumber, but 'ere the dawn of light,
What stalwart men shall perish, what warriors die tonight."

But louder still and louder, the sounds like thunder grew,
And down the rapid river the swift flotilla flew,
On either shore the foam wreathes shone like a line of snow,
But all in front was darkness, 'twas death which lay below.

Then with a shout of triumph, the Indian maiden cried:
"Listen, ye Mohawk warriors, which sail on death's dark tide,
Never shall earth grave hide you, nor wife weep over your clay,
Come to your doom, ye Mohawks, and I will lead the way."

Then sweeping her paddle, one potent stroke, her last,
Down the Falls her bark is borne, the dreadful brink is passed,
And down the whole three hundred, with quick succession go,
In the dark abyss of death, eighty feet below.

And many a day thereafter, beyond the torrent's roar,
The swarthy Mohawks' dead were found upon the river shore,
But on the brave Malabeam's dead face no human eyes were set,
She lies in the dark stream's embrace, the river claims her yet.

The waters of five hundred years have flowed above her grave,
But daring deeds can never die while human hearts are brave,
Her tribe still tells her story and round their council fires,
Honor the name of her who died to rescue their sires.

Claude Roussel

*In 1946, at the age of 16, Claude Roussel created one of his first orig-
inal wood carving reliefs based on the legend of "Malabianah"
(Malabeam). The illustration is a drawing based on a computerized
detail of that work.*

*During his 50 years of active art career Roussel has become a well
known national and international artist. He is also credited as
founder of the fine arts program and the art gallery at l'Université
de Moncton.*

Remembering the End of World War I

told by Ruth Bragdon

I remember the day very clearly. I'll tell you how it came around. People thought we were in for snow but in fact it turned quite warm. My father, Irvin, was way out in the back, ploughing. He stopped the horses and listened. There was a loud noise. It was coming from the direction of Woodstock. There were three mills up in Woodstock and their whistles were all sounding at the same time. The wind was blowing down river and we could hear it plain as day even though we were sixteen miles away.

Dad knew that there would be only one logical explanation. He unhooked the horses and left the plough in the field and headed for the house. Mama, Estella, saw him coming and thought that he had hurt himself because he was on the back of one horse with the other trailing along behind.

She went out and wanted to know what was going on. He tearfully announced "THE WAR IS OVER!" They hugged each other warmly. Then Dad hooked the team of horses and headed for Temperance Vale. That was the only place that they had a telephone.

Mama sent me over to Grandpa's and my Uncle's to tell them. They dropped everything and went to Temperance Vale. They all went to the post office and the crowd packed in to listen to what they could hear over the telephone. When they all got home, everyone got together and we had a big supper to celebrate the war being over.

The War is Over

Ralph Olive

Ralph A. Olive is a native of Saint John, New Brunswick and began his career in art in the 60's. Working mostly in acrylics, his work depicts a broad variety of man-made and natural subjects.

His paintings have been exhibited in many group and one-man shows while several of his works have won acclaim through awards. His crisp, clear style quickly became popular with private and corporate collections throughout Canada and the United States.

Escape from a German Prison Camp

by

Jack Allen Thomson

My name is Jack Allen Thomson (Reg. No. G-18437), I come from Bathurst, N.B. and I joined the Carleton-York regiment April 1, 1940. I was trained in Aldershot, Nova Scotia and in August was dispatched to Glasgow, Scotland and on to Aldershot, England.

I was trained in England as a radio operator, did guard duties and sea duties and was trained in mountain climbing. I joined my fighting regiment "The First Contingent", after Sicily was freed by the allies in 1943. Initially the army said I was too young to go, but later had a change of heart. After a good many land battles in the Apennines of Italy we pushed the Germans back. The Italians had already surrendered.

On the 13th of December 1943 my regiment went into the gully or what we referred to as "Death Valley" near Ortona where we were involved in a two day battle. That valley was so full of smoke, shrapnel and stuff flyin' that the only way you could attempt to follow one another was to put your hand on the soldier in front of you. All of a sudden the fellow in front of me disappeared. He was hit and down he went. I could barely see the guy in front of him. I had to step over my fallen comrade and rush up to get ahold of the next guy's shoulder, otherwise I wouldn't know where I was going. The smoke was so thick,

Jack Allen Thomson

the noise so loud, and the stench of blood and guts was so wicked it was enough to make you sick to your stomach or worse, go insane. I wondered if this was real or was I in a make-believe land where survival was the only thing that mattered. Conjure up your worst nightmare and we were there for real, in person.

We were being pinned down by Tiger tanks and the 90th Grenadiers. The first regiment of the German Parachutists arrived that very night. They were fresh and Germany's finest.

The next day we couldn't move and the Germans, bolstered by new troops, forced Capt. Simms and the 28 soldiers, many of whom were wounded, to surrender. This was near the crossroads of Ortona.

Some of the wounded men were sent to hospitals. Those of us who could march were taken to L'Aquila and loaded on box-cars and sent north to a concentration camp in Bavaria, Germany - either Stalag 7A or 11A. From there I was sent to a stone quarry for punishment for refusing an order from a German officer. He was going to shoot me so I decided to give in.

We had a daily quota of 15 tonnes of rock to be loaded on 5 tonne wagons and sent to the crusher. One day I nearly met my Maker. Someone had thrown his hammer in among my wagon of rocks and of course it broke the crusher. There were two guards, a manager and two Gestapo agents who marched me down to see the whereabouts of my hammer. I always took the precaution of burying my hammer because one never knew what might happen. I didn't want to be blamed for any wrong doing. I brought the Germans over, uncovered my hammer and, when they realized that my hammer had not been involved in the incident, they let me go. If I hadn't covered my tracks, they'd have shot me on the spot.

In the stalag, we were put on a starvation diet as were most P.O.Ws. We were given one loaf of bread for nine people. The bread was made of rye mixed with sawdust and flour. The way we measured each portion was with a string. We had little squares of margarine about 1 inch by 1 inch and 1/4 inch thick. We were given small amounts of jam as well. That was breakfast.

For dinner we had little potatoes. For supper we had to save a little from our breakfast and dinner, that's all we got. For drink we had something called Ersacks coffee made from dried poppy seeds. This

diet took its toll. When I went in the line I weighed 148 pounds - when I got back out of Germany I was down to 106.

I tried to escape about 5 times. The first time I tried I was in a box-car on my way north, and I did so by sawing the lock with a piece of hack-saw blade I had made from a knife I had hidden in my paybook. They stopped the train to check and found the lock nearly sawed through. That was the end of that.

I was quite sick during the time I was held prisoner as I had contracted malaria in Italy. A German doctor sat with me during one night when I nearly died. It just so happened that his son was killed in a bombing attack on England that very night.

The next day I was sent to a German hospital where, for some reason or other a Russian soldier took care of me and even gave me a portion of his small piece of bread along with my own.

I recovered a little and then suffered a relapse. I was told that I was going to die. A Scottish orderly, held prisoner, was the only "doctor" in charge. He gave me an ultimatum. He said that he had seen a doctor, back in Scotland, inject strictnine near the heart. It would either save my life or kill me. I had to sign papers authorizing a clearance on his behalf.

I said "I'm probably going to die anyway so please give me the needle."

He gave me the needle and I felt really weird. He asked me how I felt.

I told him, "I feel drunk as a pig."

He said that was good and that the drug was working. I gradually got a little better and was sent to a sugar factory.

From this work factory I planned another escape. Another Canadian soldier was sent there, a parachutist from Chatham, N.B. who had been taken prisoner at Arnheim in Holland. His name was Harold Phee. He told me that he heard through the grapevine that I was going to make another attempt to escape and asked if he could come with me. I warned him that if we were caught that we'd be shot by German guerilla fighters left behind as the Wehrmacht retreated. I also informed him that I would be in control because I knew a great deal more about the Germans than he did. I told him to trade all his clothes

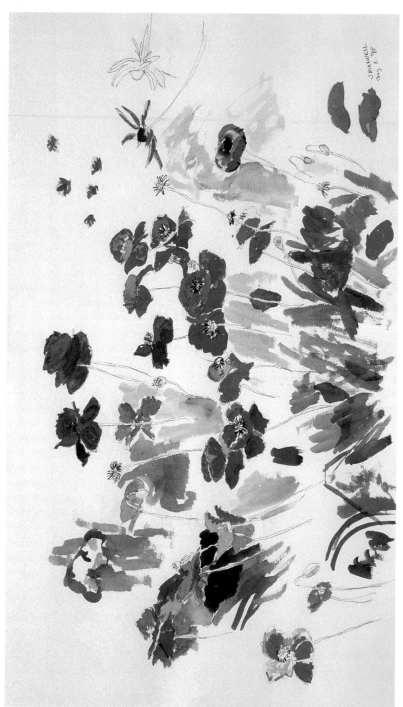

Red Poppies in a Field

for rag clothing. There were Serb prisoners working in the fields nearby and we hoped the Germans might mistake us for them.

About noon time on the 13th of April 1945 there were about 25 of us in a group set for our rations. I'd checked the cook house for an outlet in the cook's shack and found one. On that day the boys crowded around to give us a chance to get out. We looked out, didn't see any guards about and exited. We headed for the bridge which the Germans were mining at the time.

Half-way across the Elbe river we met a German tank division.

I told Phee to stand at attention with his back to the walk-rail and to salute the Germans. Thinking we were Serbs they spat in our face in contempt. When we got off the bridge we headed for the field to pass as common workers.

Phee and I soon came across a prison camp the retreating Germans had abandoned. We hammered on the door, shouting, "Canadas".

The only occupants, Russian and Polish women and children and the odd old man let us in and told us that the day before, prior to leaving, the Germans had taken all of the men and young boys out back and shot them. In those days that sort of thing didn't mean anything to me - I expected something like that to happen anytime. You know what I mean - you live by the gun and die by the gun. We stayed for the night and slept on the floor.

The next morning I decided to find out if they were telling me the truth about the massacre. We went out back and sure enough there were 137 executed prisoners, all in mangled positions. Some of the boys couldn't have been more than 12 or 14. Anyone who could carry a rifle was shot. Strange as it may seem we were unmoved by this horrible spectacle. We were so hardened by the war that tears were nonexistent.

Determined to move on, we managed to steal a team of horses accompanied by a Russian driver. He didn't want to go with us but using a makeshift knife, as a persuader, we forced him to accompany us. We proceeded down to the village where we learned, I don't remember how, that the bürgermeister had a vehicle in his garage.

I told Phee that if we banged at the bürgermeister's garage door someone would probably come down from the house with a pistol. I told him that one of us had to stand at the corner of the building as a

lookout. Phee said that he'd bang on the door. Three individuals responded, a middle-aged woman, a young woman, and a middle-aged man armed with what looked like a luger.

I told Phee to distract them and that I would grab one of the women. When they got close enough I grabbed the younger woman and put my knife to her throat. Phee screamed "Give me that Luger" but the German wasn't going to.

I drew a little blood and he handed the gun over so I let the girl go. We got the keys and found a Fiat inside - no gas. The trio pushed the car out. Once on the street the hundred or so Russian and Polish slaves who had followed us down from the prison camp helped out as well.

We didn't go too far when I spotted a tractor and said "Petro, Petro." One old fellow took to grinning. He and some of the women took some cans and got us some gas. The "bürgermeister" wanted to come with us and I said no way. We took off on the Autobaun, and when I looked back in the rear-view mirror I saw those Poles, Russians and Serbs killing the Germans.

Before we got to the first little village a tank come out pointing straight at us. We slowed right down until we got to the tank.

The driver said, "Germans?"

I said, "No, Canadians."

He said, "How do I know?" Well, we both took to swearing!

The guy said, "You must be either Americans or Canadians because Germans can't swear like that." We found out later that this was one of Patton's advanced Sherman tanks.

I told him that we needed gas and he let us fill our tank.

Before he left he said, "You own this country - take whatever you want."

I said, "We are going to find an ammunitions dump and pick up some arms."

We kept going until we met up with Patton's main army at Hildesheim - Free At Last.

Jack's Family

Here is a list of two generations of the Thomson family, most of whom were involved in the great wars.

William W. Thomson (1896-1976) fought in World War I

Bernice Ruby Thomson (1901-1967) Silver Cross Mother

Jack A. Thomson (1919 - present)

Robert Thomson (1921 - 1921) Died of Cholera

Ronald William (Bill) Thomson (1924-1945) Killed in Burma (World War II)

Allen W. Thomson (1925 - present) Navy during World War II

George B. Thomson (1929 -

John Maxwell

John Maxwell was born in Fredericton, 1934. He is represented in the Provincial Museum, the Art Gallery of Nova Scotia, the Provincial Art Bank and the Beaverbrook Art Gallery. His work is mainly involved with realism.

John Maxwell is represented in the U.N.B. Permanent Art Collection.

Missing in Action

by

Thomas Wilby, D.F.C.

I was born on Friday, the 13th of June 1919. On March 1st, 1940 I enlisted in the Royal Canadian Air Force at Moncton, New Brunswick. A great many of my boy-hood friends followed suit in joining up.

When I enlisted the recruiter told me that I had the right height and education to join the R.C.A.F. aircrew. I initially started out as a pilot and then I was transferred over to gunnery where I graduated as a sergeant/air gunner in Fingal, Ontario.

In the summer of 1941, I, along with many other R.C.A.F. airmen, was taken to Bournemouth, England, where I did operational testing on Bolton Paul Defiant planes because my night vision was good and the Defiants were single-engine night fighters.

One day a high ranking officer from the Royal Air Force strolled into the Canadian barracks looking for volunteers. In a flash I joined the R.A.F. because I knew that way I'd get actively involved in the war on the front lines.

Shortly thereafter I did a tour on the Bolton Paul Defiants. Near the completion of a series of raids I received word that I had been recommended to be commissioned as a pilot-officer. After flying single engine planes all the time I was sent to Yorkshire in March 1942, to become the tail-gunner in a 4 engine plane called the Halifax Bomber

Tom Wilby

Mk. I. It was unusual in a way as I was the only ranking officer in the plane. All of the other men were sergeants and, as it so happened, they were also Canadians.

On my 13th bombing mission, on December 11, 1942, 20,000 feet over eastern France on our way to northern Italy, one engine cut out because the temperature at that altitude was in the range of 50 degrees below zero. We were carrying a full bomb load at the time. The pilot asked the navigator for a course to home. The aircraft went into a tail-spin and the control of the aircraft was lost. I tried in vain to make contact with the pilot on the intercom to see what was going on. Then a distraught voice came through.

"BAIL OUT, BAIL OUT, BAIL OUT," and the voice died away.

I tried again to make contact - but to no avail.

Well, I had never used a parachute before so I was more than a little concerned. I unhooked my oxygen mask and prepared to jump. I opened the turret doors, grabbed my parachute pack and adjusted one clip to my harness instead of the two. I said a quick Hail Mary prayer and bailed out. After several seconds of panic and despair the parachute finally opened and down into the still of the night I drifted until I hit a tree and landed at the edge of a field. I would later learn I had landed near the city of Bourg-en-Bresse.

At first I thought that I had just bruised my leg badly and that I was okay, but I couldn't stand up. In the distance I could glimpse a faint light and crawled painfully toward it. When I finally reached a house, the occupants came to the window of the back porch, looked at me and said,

"Allez-vous-en!" (Go Away).

On my battle dress, I wore those Canada patches on my shoulder that glowed in the dark and when the occupants of the house had been able to get a closer look, I could understand they were identifying me as being a Canadian. They immediately opened the door and treated me to a little wine and food and allowed me accommodation for the night.

The next morning a doctor arrived confirming that I had a broken leg. He said that he'd go get some plaster of Paris to set the leg but he never came back. Instead I was picked up by two uniformed Gestapo agents who took me into town to a building, stripped me down and

interrogated me. Then I was locked in a basement with several other prisoners, all of them emaciated. I remember how happy they were to get a Lucky Strike cigarette from me. After a couple of nights of confinement I was taken to a private room where my leg was put in a cast.

When the Germans found out that I was a pilot officer I was given preferential treatment and even saluted. I was also fortunate in being guarded by a soldier who had been wounded and captured by the Canadians at the famous battle at Vimy Ridge in World War I. Because of his excellent treatment as a P.O.W. he was more than kind to me. For example on Christmas Eve he brought me a boiled egg and a slice of black bread which were luxuries at the time.

But this relatively kind treatment wouldn't last long. One day I was interrogated, accused of being a spy, and threatened to be shot in the court yard below if I didn't give the Gestapo information with regard to the rest of the crew. The officer pointed through the bars on the window to the post down below. There was no doubt in my mind that that was where executions were carried out. My captors even went so far as to bring in a priest and two altar boys to administer last rites. I was mortified but my guard gave me a sign which I understood to mean that the officer was only bluffing.

I stayed in that room for around six weeks. It was the French doctor who had put the cast on my leg who was a principal player in orchestrating my escape unbeknownst to me at the time. Fortunately, the doctor had split the cast down the back so that I could remove it and massage the muscles. Later, he gave me a key for the door which I hid inside my sweater and I was informed that just prior to being transferred to a stalag I was to hear a special knock (a V in morse code), a prelude to escape.

Finally the day came and the knock sounded and a stranger appeared at the door. I froze at first but quickly regained my composure. I sprang into action, took off my cast and exchanged clothes with my accomplice who instructed me to be on the look-out for two guards. Once I was safely past them, I headed directly to a garbage truck, manned by two fellows who turned out to be my accomplices. They motioned for me to climb into one of the garbage cans. What a stench! I quickly climbed in, they put the lid on and we started down the road.

By this time the sirens were blaring from the internment camp. A short time later the truck ground to a halt.

I could hear in German "Achtung, Achtung" (stop). The soldiers started their search but the foul odour proved not to their liking and they soon gave up. The worst part of my ordeal was being in that maggot-infested garbage can for two hours. The filthy white larva literally covered me from head to toe. They were crawling on my back and in my ears - everywhere. My body was loaded with them. Finally the truck stopped and the men washed me down with buckets of water.

I was ushered to a "safe house" for six weeks or so just outside of Bourg. The French underground kept transferring me from place to place. Soon I wasn't too far from Lyons. But before too long I decided to strike out on my own so I stole a bicycle. I did all right going from house to house. Then I approached a railway worker and told him that I was a Canadian and he gave me some money for a ticket. I ended up on a train and thus travelled the short distance to Lyons.

When I got there I explained to yet another railway worker who I was and he allowed me to board on another train going to Paris. On the train I met up with two French resistance fighters, Henri DeBerge and his brother-in-law, who attempted to help me. The plan was that I was supposed to pretend to be a René Martin, a mute.

On our trip north the train was stopped at a railway station for a routine check. My two assistants were on either side of me as we were forced to line up. I gave my passport with the name René Martin. A French officer was asking for identification, accompanied by two Germans with loaded pistols drawn.

The French officer looked at me and said, "Votre nom s'il vous plaît."

I replied, "René Martin".

He caught on right away as he studied the identification.

"Oh, my God", I thought, "I've blown my cover." I could feel the tension in the air. The Germans didn't know what was going on. They didn't know any more French than I did.

He said, "O.K. monsieur" and he closed the folder in my hand squeezing the side of my hand signalling that he knew I was an escapee. He continued on to the next person - I nearly dropped to the ground.

We still had one more stumbling block to cross - I hadn't a ticket and needed one to pass through the exit gate.

Henri's brother-in-law went to the ground and faked an injury, drawing his own blood. A crowd gathered and my other angel of mercy, Henri, grabbed my hand and off we ran.

As far as I can remember it took about a week to reach just south of Paris by walking, cycling and travelling on the train. We went from "free" France to occupied France to make a final escape. A note of interest is that I noticed more German soldiers in "free" France than in occupied France.

At this point I was still being guided by Henri and his brother-in-law whom we rejoined on the train. From Paris we took a train to Tourcoing on the Belgium border, where I stayed at another "safe-house" near Roubaix. Upon arriving at Tourcoing I learned to my dismay that the initial plan of escape across the English Channel was cancelled.

Plan B came into play which necessitated the long and highly dangerous trip back to the south of France, this time in the direction of Toulouse. In Toulouse, eventually I met up with my guides, Florentino and Franco who were to guide myself and three others, two Americans and one of the English R.A.F. spit-fire pilots, over the Pyrenees by way of the Comet line.

For this journey each man wore a white scarf and was told to stay close to each other. Batons were used to keep us in a chain-like formation in case one person lost his footing. The journey was difficult because of the cold and darkness. After a difficult journey we arrived at San Sebastian in Spain, jogging the last two miles. We arrived at a small farm and we all fell into a deep slumber. The date was April 30, 1943 - my wife Del's birthday.

From San Sebastian, we were taken to Madrid where to my astonishment I met up with my R.A.F. Station Commander who also had been shot down and escaped. "You were the only one that left your plane," he told me, "and, if I remember correctly your crew managed to regain control of the aircraft but were all killed on their next mission."

Later, back safe and sound in London, I was interviewed by the Royal Air Force Intelligence Service. They asked if I ever saw any cats

or dogs in France. I replied that that was a foolish question but upon reflection realized that I couldn't remember seeing any but perhaps I'd heard a dog. I later found out the food scarcity was so extreme that the cats and dogs were eaten to avoid starvation. A note of interest is that I went into the war weighing 175 pounds and came out weighing 125 pounds.

Like father - like son. Ed Wilby, at age 16, signed up at Bangor, Maine to join the American paratroopers and at age 17 fought in Vietnam with the 73rd Airborne Division.

Phil Vincent

An eye for detail and a love of history makes a Phil Vincent illustration authentic. A native of Saint John, New Brunswick, his background in Art History and Graphic Design was developed in Charlottetown and Halifax colleges. Today, Atlantic themes dominate portraits, prints, calendars and a wide range of commissioned work.

Willard Miles Jenkins M.D., C.M. (1884-1968)

Told by Tom Scovil

The life of a country doctor in New Brunswick in the 1920's and 30's was a formidable task. The story of Dr. Willard Jenkins is a case in point.

Willard grew up on the Belleisle River at a place called Jenkins' Cove. His calling took him to McGill University in Montreal where he showed great promise as a surgeon. Upon the completion of his studies, Willard was asked if he might want to remain in Montreal. Later in life he told his close friends back home that the only thing that stopped him from practicing medicine in Montreal was the water!

Willard bought a farm and set up practice in Gagetown where for five decades he performed a great service to the community. At times he made his rounds on horseback, at times in a sleigh, in dangerous conditions, journeying many miles from Gagetown in all directions from French Lake to Welsford to Fredericton Junction. He was loved and respected in the community and had a heart of gold. He was a big, robust man and was quite a welcome sight to the sick travelling in his sleigh adorned with buffalo robes to ward off the cold. Tom Scovil remembers Dr. Jenkins in the following anecdotes:

• • • • •

I was just sixteen attending school here in Gagetown. One Saturday afternoon the Doc came into the store for some tobacco or cigars. He asked me if I wanted to go for a drive.

I said, "Yah."

It was Saturday and he told me to be up to his house at 2 o'clock and to bring plenty of clothes. I arrived just in time to see this chap that looked after the house bring a pair of horses from the barn and hook them up to the sleigh. We took off and headed for Upper Gagetown first and then we crossed the river to McGowan's Corner. The reception we got showed that Dr. Jenkins was a popular man. There were people coming down the driveways with money for their bills, some just welcomed us and others that were sick were given medicine. I thought it was pretty funny one time when he gave out a receipt, jammed the money in his pocket without counting it and said, "It's a better life than being in a coffin," laughing foolishly to himself.

We continued on our journey and by and by we stopped at this farmer's house to rest the horses. Dr. Jenkins asked the man if he could take him on down the road because his own horses were spent. When the farmer answered in the negative the Doc told him we didn't need his help anyway and onward we journeyed. About midnight we arrived at a patient's house at French Lake. I remember having to bunk up with the old Doc for the night. The next morning after breakfast and some doctorin' we headed back to Gagetown.

• • • • •

The Doc was a man that enjoyed companionship. One winter's day he had to go way down to Hampstead. He was travelling by sleigh and stopped at an acquaintance's house. He told the fellow that he wasn't sure if the ice on the river was safe so would he be so kind to bring his axe and accompany him. They had to cross the St. John River at Wickham or someplace near there. Well, the old Doc told him that he was in a hurry and that maybe they would check the ice on the way back. Yah, the old Doc was quite cute that way.

· · · · ·

One day the Doc got a call from a boss somewhere. He reported that one of his employees on the job was sick and couldn't work. The Doc came to see the young lad.

He said, "What's the matter with you young feller?"

He replied, "They aren't payin' me, I'm not gettin' up until they do pay me."

The Doc answered, "Move over - they ain't payin' me either."

· · · · ·

One time I ran into the Doc and complained about my sore throat. He gave me some pills and reassured me that I'd be o.k. I didn't get any better so my mother made an appointment for him to come see me.

The Doc told her that I was o.k. two days ago and that he'd be over that night.

Well, when he came over there was a fellah named Frank Fox with him. The Doc told Frank to go wait in the living room and that he wouldn't be too long.

Anyway, he came upstairs and looked down my throat and said,

"You have got a bad looking throat all right. Here take some of these pills - I'll see you in the morning."

Sure enough around 8 a.m. the Doc showed up.

He told me to open wide and close my eyes. He went in there and slit the inside of my throat this way and that way. He told me to spit that stuff out and that I'd be all right. He knew his business.

· · · · ·

Lloyd McKinney ran the general store here and always made a rink out back for the kids to skate and play hockey. The kids brought this young fellah up to the store with a broken leg. They laid him out on the counter and called for the doctor.

Well he came down right quick and saw that there were kids all gathered around. He cleared them back and looked the leg all over. He motioned to one of the menfolk to prop the boy up holding the boy right around his shoulders.

He said "This might hurt him a little - but he's bred to be tough." By golly - he grabbed a hold of that boy's leg and jerked it. The Doc yelled, "Yah, that's all right." He put the cast on and sent the boy on his way.

• • • • •

One day Jim Hamilton, a prominent citizen, had a ruptured appendix. Dr. McGrand from Fredericton Junction, who helped Dr. Jenkins on occasion, arrived first. Dr. Jenkins showed up several minutes later.

Dr. McGrand stated "We can't operate on him here - we'll have to take him to Fredericton."

Old Dr. Jenkins analyzed the emergency of the situation and solemnly declared,

"Ya, we can operate on him here - right here - right in this bed!"

So they put Jim to sleep and Doc Jenkins climbed into the bed and performed the operation in a kneeling position.

• • • • •

McGrand was a good Catholic and Jenkins didn't know what religion he was - a good Baptist maybe. They were going across the St. John River in the spring of the year and the ice was in a delicate state. Old Doc Jenkins was grumblin' about how lucky they'd be if they got across. Dr. McGrand wasn't amused and stated angrily "Turn the horses around - I'm not ready for the graveyard. There's no need of taking chances."

Old Doc laughed aloud and yelled "We'll be alright. You pray to the Virgin Mary and I'll pound the horse with this whip."

• • • • •

One day the Doc had a little Indian girl in his office to extract a tooth. I forget if he didn't let it freeze enough or somethun'. It got to hurtin' her pretty good and she got out of the chair and took off runnin' down the street. The old Doc ran to the door and yelled at the top of his lungs so everyone could hear, "Come back, come back, I'm a good dentist."

· · · · ·

One day the Doc had this patient in his office. The Doc also had a friend waiting to go with him to the horse races in Fredericton. The Doc knocked the patient out and performed a surgical procedure. Time was of the essence and the pair of men were getting antsy to get to the races.

His friend asked, "Are we going to be able to go soon?" Old Doc he had a solution for just about any problem. He spoke up,

"I'll tell you what I'm going to do. Let's put him under the tree. It's nice and warm out - he'll come to by and by."

Well, to make a long story short, the men didn't miss much of their races.

· · · · ·

This old farmer was takin' these dizzy spells but he wouldn't go to see the doctor. One day he inadvertently ran into the doctor on the street whereupon he took a spell.

Old Doc said, "What's wrong with you?"

The old farmer said, "I don't know."

Doc said "I know what's wrong with you. I'll give ya somethun' - your liver ain't workin' right." So the story goes that the farmer went down to the Doc's office and the Doc poured this stuff out of a big bottle into a little bottle. He took that until he died which was years later.

· · · · ·

The old Doc was drivin' by his farm one day accompanied by his trusted nurse. The man he had engaged to do the farmin' was doin' a fantastic job and Dr. Jenkins was moved by what he saw.

He pulled his team to a halt and beckoned his farm-hand over. He declared, "By God ya know I'm the luckiest man on earth. I've got the best farm man in the country, the best nurse in the country, and the best bull in the barn."

Russell London

Russell London was born in Bathurst, N.B. in 1944. He has been a professional for 7 years. He was a co-winner of the 1995 River Currents Juried competition. His work is mainly involved with realism.

A Firefighter's Story

A firefighter's job is one to be proud of. The profession is a brotherhood, it's about being part of a team, individual relying on individual in crucial situations. Firefighters, men and women, are willing to pay the supreme sacrifice, if need be, in fighting the red-devil. In a real situation one can't see past the hand in front of one's face. Masks could break, buildings could cave in or any number of other misfortunes might occur. Firefighting is about acts of heroism, bravery, noble deeds, team work and satisfaction in helping people. The proudest moment for a firefighter comes in knowing that he or she has played a role in saving someone's life.

In 1997, Harold Doherty was inducted into the Provincial "Firefighters Wall of Flame", an international award, for over 50 years of service, a prestigious honour indeed. He has also received numerous other distinctions and awards for a job well done, above and beyond the call of duty. This is his story.

• • • • •

My name is Harold Francis Doherty and I was born in Fredericton on the 16th of March 1914. I probably got started in the fire-fighting business because of my father Thomas C. who was a volunteer. It just so happened that the house where we lived on Brunswick Street was owned by the fire-chief whose name was Harry Rutter. I remember

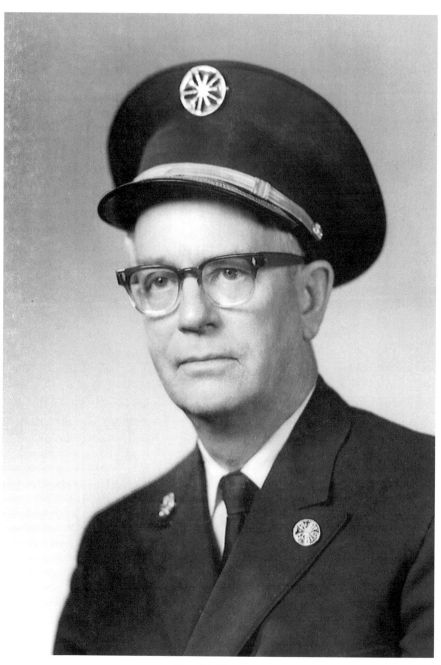

Harold Doherty

there being a big gong at the foot of the stairs connected to the fire station. I can still see my father coming home from fighting a fire in the winter time. There was no special clothing except perhaps Dad's black derby hat. I can still see him standing in the back shed with his coat and hat frozen stiff as a board. Mother had to take the scissors and clip his coat off after she had tried using hot boiling water on it. It was the only way to get him out of it. That stood up just like a tee-pee for two or three days.

My first visual memory of the fire department was at the old gym theatre which housed the fire-fighting equipment. Mother took us out to the corner of Brunswick and Carleton Street so we could watch the men in action from a respectful distance. That was very exciting for a boy like me.

I got my start working as a volunteer with the fire department at the age of 12 or 13, just taking the place of anybody who went away. At that point in time there were only three regulars: the two men who drove the trucks, a ladder truck with two horses and a hose wagon with one horse, plus Leo Ward who drove a single horse.

Eventually in 1916 the Department got a chemical truck that was chain-driven, bought in Massachusetts. It had hard tires and direct drive. It may sound strange but if you wanted to go left you turned the wheel right. In 1919 a big pumper was delivered by box-car to the railway station at York Street.

Until the 1940's our equipment remained quite primitive. We had heavy, heavy helmets, special coats and just ordinary boots - no rubbers. We used to have an outside alarm, a big horn, and code 4-4 blasts of the horn meant that the volunteers were wanted at the fire station. At that time we used to go out on searches for lost persons as well. Sometimes people today remark, "Look at all of those buildings that you lost in the old days", but they don't take into account the fact that our equipment was meagre and that our staff was minimal. One man had to stay with the truck which left one man to work the hose until the volunteers arrived on the scene. I remember losing a house out in Forest Hill for the sake of a couple of gallons of water. We had the fire down and almost out when we ran out of water. Shortly thereafter we went to Horsnell's Iron Works and drew up plans for a tanker truck. We had one built for each side of the river and they certainly helped a lot.

I started working full-time as a fire-fighter in May 1942 and in July of that year I volunteered to go overseas. But my career as a firefighter wasn't interrupted. I joined the National Fire Service in England. We were involved with putting out fires in buildings, protection of vehicles and so forth - just regular duty. The most memorable event was June 6, 1945 - D - Day. It was something that you would always remember. Thousands of allied planes blackened the sky. The whole country was absolutely wild with excitement.

I came back to Fredericton in April and by August 1945 I was appointed Fire Chief, a position I occupied until 1977. I didn't own a car when I became Fire Chief and when there was a fire on the other side of the river I had to take a taxi. That situation lasted for two years until 1947.

Initially we had just one station on King Street but with amalgamation we combined forces with the Northside where Gerald Ashfield had been Chief. It was in his garage that we housed our only fire truck.

Our first fire station in Devon was a little building at the corner of Gibson and Union Street just big enough to house a truck. Our sleeping quarters were upstairs and we had to go up a ladder to get there. It was just one big room. Eventually we were fortunate to get some 2 x 4's so we could put a partition up. Our first floor covering was roofing paper - no toilets - no running water. For washroom facilities we had to go next door to Arty Voi's garage. It was all very primitive.

One day, an odd and potentially dangerous situation occurred. Our old Ford fire truck was in the grease-pit with the wheels off. We were fixing the brake lines. As luck would have it we received a call but, thank God, it turned out to be a false alarm. Anyway, we would have had to wait until we got the wheels back on before we could have responded.

As Chief, I was allowed to choose my own men. Over the years as the Department grew I tried to get individuals from various trades such as electricians, plumbers, carpenters, you name it. The first man that I took on permanent on the Northside was Babe Allen. One day Babe and I got some red paint and painted the truck. We had just finished and were washing out our brushes when we got a call from up on St. Mary's Reserve for a brush fire. The truck, of course, was still dripping wet. You can imagine what the truck looked like when we

FREDERICTON FIRE DEPARTMENT
P. Holt '98

returned to the fire station, covered in leaves and branches. We took it back, stripped it and went at it again.

I remember another comical incident. There was a cat up in a tree on York Street and we did everything in our power to get it down. We put a ladder up but we couldn't get near it - it would scratch the daylights out of you. We had a 1 inch power hose which we used to spray the cat but even that wouldn't budge the stubborn beast. Hedley Forbes came around the corner, called the cat by name, and down it came!

When I was fighting fires my wife Margaret was busy looking after the family and worrying about my safety. When I was out late on a call, sometimes she would stay up late at night praying, ironing clothes, cleaning the house or washing the floors, anything to keep busy. I did my best to inform her as to how the job was going.

For my first 13 years, I was pretty well on call 24 hours a day. If I wanted time off City Council would have to give their approval. On the whole, the City Council were very supportive over the years. I learned pretty quickly that if I needed two of something I'd ask for three. For instance we used the buddy system when entering a burning building and the Council wanted to supply only one mask. I gave strict orders that no individual was to enter a burning building alone no matter what the circumstance. I informed the Council that they could hold off and wait another year to buy the two masks but that would mean that no fireman would ever enter a burning building. The Council quickly changed their tune and we got our two masks.

Our Department was the first in New Brunswick to use the clear plastic to do salvage work, following a fire. Prior to this we used heavy canvas to cover furniture. The man or woman of the house might want a certain item. It was much easier just to look through the plastic rather than turn the house upside down. One item that we always tried to salvage was the woman's house plants. We figured that the woman probably talked to them when she was washing the dishes.

Parents and teachers, tell your children about a joke that killed a man. It happened here in Fredericton 71 years ago. My dad was helping out that night. George Clynick, a shoemaker and the father of a young family, was a volunteer fireman. When alarms rang in, the old chemical truck would slow down but not come to a complete stop at the corner of King and Regent, handy to where George was taken on. George would jump up on the side of the fire truck. He'd done it safe-

ly many times before. On this particular night he slipped, hit his head on the side, and died instantly. This was the first fatality in the Department. To make matters worse - it was a false alarm.

Vincent M. Porter (1928-1974), Gerald Trecartin (1943-1975), Benjamin J. Kerton (1921-1976) have also died in the line of duty. Their names along with George Clynick's (1880-1927) and the following poem are engraved on a memorial on the up-town Green in Fredericton.

A Firefighter's Prayer

When I am called to duty, God
Wherever flames may rage;
Give me the strength to save some life
Whatever be its age

Help me to embrace a child
Before it is too late;
Or save an older person from
The horror of that fate.

Enable me to be alert,
To hear the weakest shout,
And quickly and efficiently,
To put the fire out.

I want to fill my calling and
To give the best in me;
To guard every neighbor
And protect his property.

And if according to Your will
I have to lose my life,
Please bless with Your protecting hand,
My children and my wife.

Peggy Holt

Peggy Holt has a studio at Gallery '78 where she works in water-colour, liquid acrylic and collage. She has been selected to show her work at two McCain Competition exhibits at the Beaverbrook Art Gallery. Her work has also been shown at the National Exhibition Centre, the Wu Centre and Ecole Sainte-Anne in Fredericton, at the Aitken Bicentennial Centre in Saint John, and Sunbury Shores in Saint Andrew's By The Sea.